Hans Hartung

Paintings 1971 * 1975

The Metropolitan Museum of Art,

New York

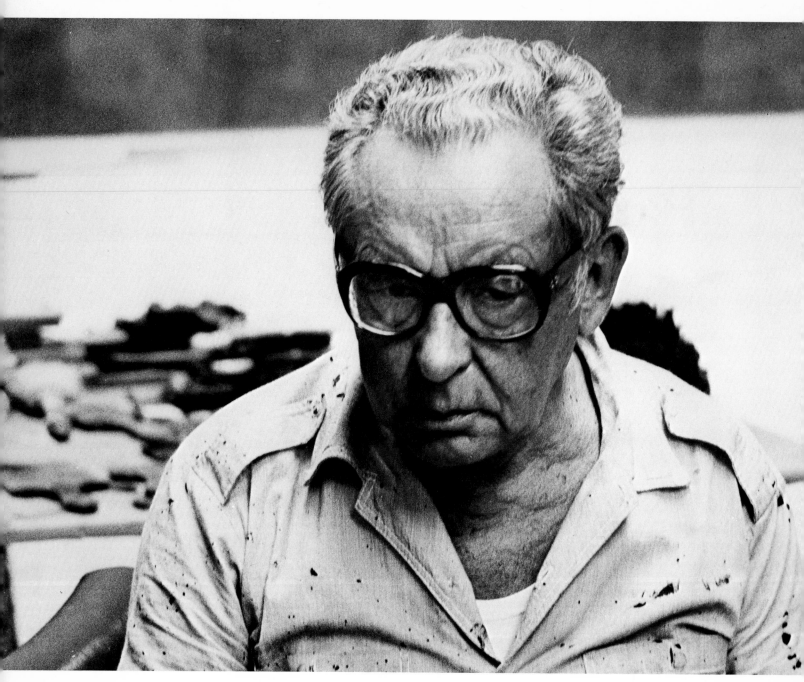

Hans Hartung

Hans Hartung

Paintings 1971 * 1975

October 16, 1975–January 4, 1976

The Metropolitan Museum of Art

Catalogue designed by Yves Rivière, Paris

Printed in Switzerland by Imprimerie Paul Attinger, Neuchâtel

Color plates by Atesa Argraf, Geneva

Published 1975

Library of Congress Cataloging in Publication Data
New York (City). Metropolitan Museum of Art.
Hans Hartung.

Bibliography: p.
1. Hartung, Hans, 1904 –
ND 588.H34N48 1975 759.3 75-31609
ISBN 0-87099-145-0

Acknowledgments

Exhibitions of the recent work of mature artists take at least three years to plan and to realize. The reason is always the same: a silent conspiracy between the artist and the curator postpones the show at least twice so that the artist can produce new and still newer work. I would like to thank Hans Hartung for his unflagging interest in this exhibition and congratulate him on the vigor and variety of his recent painting. Several visits to his Paris studio and a day viewing new paintings at the handsome complex of house and studios in Antibes, for which Hartung served as architect, were made memorable by his hospitality and by that of his wife, the painter Anna-Eva Bergman.

Myriam Prévot-Douatte of the Galerie de France has provided constant contact and excellent documentation, always with grace and generosity. John Lefebre first encouraged me to see that Hartung's recent work was undervalued in New York and introduced me to the artist in 1972.

Several biographies and bibliographies of Hans Hartung have appeared in English; we have refined and updated them. Lowery Sims, Assistant Curator of

Twentieth Century Art, helped with the biographical notes, and Kenneth Silver, a graduate student in art history at Yale, reexamined and clarified the bibliography. Michael Sheehe helped plan the installation, Shari Lewis edited the catalogue, and Susan Carr kept track of the endless details that arose in connection with this exhibition. Christopher Scott read the introduction and suggested improvements which I have incorporated. All have been cheerful and devoted companions, and I thank them.

Hans Hartung: Paintings, 1971–1975 was made possible by a grant from the Georges Wildenstein Foundation in Paris. Daniel Wildenstein's enthusiasm for Hans Hartung's painting is heartwarming; he is uniquely placed to recognize both the traditional values and the innovation in the work. We are grateful for his support.

Henry Geldzahler

Curator

Department of Twentieth-Century Art

Introduction

Hans Hartung is a painter of international importance whose work is as yet insufficiently known and appreciated outside Western Europe. There is, for instance, an American art public familiar with a few paintings from a short period in the 1950s, the paintings of "long grasses." These are elegant and splendid, an inspired moment, but hardly the whole man. Art is not necessarily exportable. In the twentieth century we can point to many national heroes whose work falls upon deaf ears or blind eyes beyond their respective borders. In some cases the work is simply not good enough to command wider attention. In others it must become familiar over long enough a period to wear down local prejudice before it is given its due. Hans Hartung's work has the intelligence, force, and wit to leap beyond local boundaries. Hartung made the transition from Germany to France via Spain, and he became one of the most highly valued members of the School of Paris, a difficult fraternity, named after a city, but as truly international as any artistic designation of our time. It is high time that his life's work, especially the art of his recent years, be esteemed internationally at its true value.

It is noteworthy that Michel Seuphor quotes Hartung as saying that his first sale was to the American collector and painter A.E. Gallatin in 1936 for his Museum of Living Art (now housed in the Philadelphia Museum of Art). One hastens to

add that except for such isolated instances as the Hartung exhibition at the Houston Museum of Fine Arts in 1969, American appreciation of Hartung's work has not kept pace with his achievement.

Hans Hartung is seventy-one years old. Like certain artists of our time—Henri Matisse, Joan Miró, Hans Hofmann, and Willem de Kooning (Hartung's exact chronological contemporary)—Hartung has continued to develop along highly original, unpredictable, yet, in retrospect, inevitable lines. Since he was sixteen, he has been an artist of exquisite sensibility, able in his early years to imitate what he needed—Rembrandt, Goya, van Gogh—and to make it his own. His paintings surviving from the 1930s bear witness to his contacts with the work of Kandinsky (he once heard the artist lecture in Leipzig, and, according to one source, found him dry) and with the Surrealists, especially Miró; yet at no point can we mistake a Hartung, once we have sensed the uniqueness of the work. I have chosen to concentrate on the works of the past five years because they are unfamiliar to the American audience and because they are both more audacious and more refined, both grander and simpler, than any of the work of his generation in the School of Paris.

In a recently published interview, Hans Hartung reminisced about his early career: " ...for about seven years, from 1925 to 1932, I did studies; I made pictures in the style of van Gogh, I did Picassos, I made copies after Matisse, Goya, Hals, everybody. I wanted to understand each of them completely, because only through painting like them or by copying them correctly and then

painting like them could I comprehend in their work that which had not been used up, and I wanted to compare all this to what I thought my art might replace it with before I in fact made my own art. Therefore, it's the opposite of anarchy, at the same time that it is anarchic. You see, when you want to destroy something, you want to be sure that what you put in its place is justifiable and more true than what existed before, or at least as true. I think that's an absolute necessity that precedes any license to change things, or upset them."[1] This is the perfect rationale of that strange but indispensible phenomenon, the conservative innovator—the original artist who is thoroughly versed in the history of art and who innovates out of the necessity, as Ezra Pound said, to "make it new."

From 1932 to 1934 Hartung lived on Minorca in the Balearic Islands with his wife Anna-Eva Bergman; he speaks of these years as a return to his early abstract studies, the best of which are the very beautiful expressionist watercolors he painted in 1922 when he was eighteen years old. He did them in isolation, unaware of recent developments in European abstraction. Thus when he returned to them in 1933, after having served his self-imposed apprenticeship to the masters, he had acquired a new kind of visual outlook, a sophistication which combined with his Northern expressionist instincts. He credits this training with the feeling for the "correct" proportions which are so characteristic of his work. The years between his stay in Spain and the end of World War II were completely "knocked out," as he says; he refused to return to Nazi Germany, his citizenship was unclear and a major problem during these years, and he could produce little work. He was an amputee when he came back from the war, and

in 1946 he was awarded French citizenship for having served in the French Foreign Legion. Since that time he has been claimed by both France and Germany as an accomplished native artist.

Hans Hartung never paints by formula or in a series, although there are recognizable devices in his work, techniques of handwriting that give free expression to the vocabulary and grammar of his invented language. But such techniques are never stale or repeated; they are newly created each time he works, whatever the medium. "Ce que j'aime, c'est agir sur la toile" ("What I like is acting upon the canvas")[2] is perhaps the most often repeated remark of this artist, who rarely speaks of his own work or cares much what others write of it. One senses the truth of that remark; he is talking both about what he likes in the act of painting and what he likes in life itself. That is how important painting is and must be to so total a master. "Ce que j'aime dans la vie, c'est agir sur la toile" ("What I like about life is acting upon the canvas"). (I have taken the liberty of adding the underlined phrase.) To anyone who has spent time with Hartung, its truth is striking.

It is no dishonor to the man to say that Hans Hartung is the greatest connoisseur of his own work. Anyone who has tried to pry one of his best works from him can attest to this fact. In a way this has worked to the detriment of his reputation, for in order to appreciate the man to the fullest, one must visit him in his home and studio, a privilege accorded to few; Hartung is a private man more interested in continuing to paint than in crooning over his past. If this seems a contradic-

tion—keeping the best he has done in the past while focusing entirely on the present—Hartung is a big enough man to encompass such apparent contradictions. He envisages a Hartung center or museum where one day the general public can see what he has achieved in its entirety and at its best.

Much French writing describes Hartung and his career in rather flowery terms through the events of his own life: wars, destruction, separation, the death of his father, the amputation of his leg, and so on. All this may work on one level, but it is abundantly clear that one can come to the paintings with none of this historical or biographical baggage and still see something quite different: the intelligent and witty, yet deeply felt, exploration of a personal expression which follows its own ineluctable laws. I think biographical background is informative and helpful, and even pertinent at times, but finally we are always left with that permanent residue of the artist's experience, the work of art. And it is the work of art which, to make its way successfully into the future, into the art historical canon, must do so on the strength of what it expresses and essentializes. The loss of van Gogh's ear would have been quickly forgotten if the paintings hadn't insistently called attention to themselves. So much for amputated legs.

I see the central repeated image in Hartung's work as abstracted depictions of landscape, "long grasses," a lovely term that matches the elegance of the image. In the literature, however, it is often repeated that when he was young Hartung wanted to capture lightning in his drawings. "When I was a child, I was much influenced by lightning. At the age when most children are drawing stick

figures, I filled whole notebooks, and a great many of them at that, with all the lightning flashes I had seen. Seen or not seen. From top to bottom, always lightning, lightning, lightning. Probably this is still present in my style of drawing, which very often has this zigzag aspect of a line leaping across the page."[3] Lightning fascinated and thunder terrified Hartung. Thus the paintings have at their root an element of primitive magic; when they capture these violent natural phenomena, they also domesticate them. This helps to account for the disparity between what has been described as the violence of Hartung's subject matter and the essential tranquility of the paintings themselves.

Between the sketch and the painting, says Hartung of his working processes, is interposed a long period of reflection. "The idea must be allowed to ripen, to be pushed to its limit. I must be able to concentrate on and isolate its essence... and yet, at the same time, to retain in the execution the fresh, direct and spontaneous character which is the essence of the improvisation. To keep all this in balance, long effort is always necessary, but it must not show. Is the public invited to rehearsals? That doesn't stop a good actor's or a good musician's preparation from being long and profound in order that he be capable of giving the impression of improvising with a controlled perfection that conquers us. That is the real technical problem. First, before the blank canvas I feel the need to make a certain spot, a certain color, or a mark. The first marks lead to others. Colors lead to signs which in turn suggest marks whose role might be to support or to contradict what already exists as much as to stabilize the painting. In any case, I act at first with complete liberty. It is the work, as it goes along, that limits my

choices."[4] He goes on to say that to separate the roles of the unconscious and of reason in the process is difficult. They are both present at each instant.

This is an unusually long statement by a man not much given to making statements about his art. It indicates rather forcefully, I think, that he sees his work and the processes that produce it in formal terms, in modernist terms, let us say, rather than in the existential, humanist terms of those who see his private life—the war and so forth—as motivations for the paintings. This does not give weight or credence to either interpretation. Both approaches reinforce each other if they can be presented judiciously, but one can hardly imagine Hartung pointing to a painting and saying, "This was my despair at the Spanish Civil War, and here I agonized about the atom bomb." In his approach to his work, he is a dedicated, even obsessive professional whose daily concern is the making of art. He is a modernist artist in the sense that his truest and most consistent subject is the making of his art.

Music and science early caught Hans Hartung's attention and imagination: Leipzig in general and his family in particular were very much involved in and surrounded by music. His scientific bent was somewhat discouraged when he came close to failing mathematics, thus endangering his baccalaureate degree. However, a family friend had a telescope and from that time astronomy has been a lifelong fascination for the artist. Hartung keeps abreast in general terms, as does any educated modern man, of scientific advances, but he does not merely illustrate them in his work. Rather he internalizes this information as he does

everything else. Politics, literature, daily life—all feed the imaginative life on which he draws intuitively at the moment he is "acting upon his canvas." Hartung says, "I can't abide paintings that are meant to be astronomical or physical. It's a new and senseless kind of illustration, a figuration that is meaningless. If these things penetrate your spirit, if they help form your thought, O.K. But if some artist paints microbes that he's seen under a microscope… he'd be better off painting the ladies of Montmartre or Montparnasse."[5] There are clouds in Hartung's work, there are beehives, there are dense astronomical configurations, there are seashells; but all these are metaphorical descriptions of various abstract means that the artist has invented with his brush and spray gun. They are not scientific illustrations, nor have we used them as paintings or explained them away as subject matter when we have made the metaphorical connection. Hans Hartung's work is more firmly rooted in the history of art and the art of his time than these current scientific metaphors might suggest.

In the same interview, after explaining that seeing a painting of a distant mountain or of water is not the same as the experience of walking in a forest or swimming weightlessly in cold liquid, Hartung indicates that much more information gets into a picture than what we know merely through our eyes. "Seeing is not a total experience. Our experience is made up of all we have lived. I'm cold, I'm hot, I'm in pain, all the shiftings of my organs, those are the things which lead me to an apperception of the world. When, as babies, we enter the world, we cry, because it is a terrible thing to be alive.… What we feel is much stronger than the reds and blues we see around us. For us as painters, all that must be expressed.

Experience reduced simply to vision allows us to know neither the object nor the world. I don't exclude seeing, obviously, but sight is not our only mode of perception."[6] Hartung is, of course, speaking of all the other kinds of information and feelings and decisions that get into the work: the rhythms, balances, and moods, both physical and spiritual, that control the work. The artist can be frenzied or he can be serene; he can be angry, irritable, melancholy, lighthearted, or spiritually uplifted. On another occasion[7] Hartung talks of gravity, the unconscious effort to find the equilibrium necessary to stand up, as an essential factor in painting. All these are experiences and feelings that get into "abstract" art; art made by human beings at specific moments in their complicated lives. Only dead formula painting, academic art at its worst, eliminates these possibilities of feeling. Thus a simple line may be violent, passionate, bristling, fragmented, calm or expressive in a number of ways. Abstraction is translation of feeling, and now that the pioneer era of formal criticism is waning, it is precisely these feelings—as the subject matter and content of abstract art—that provide the greatest challenge and opportunity for critics. Of course, there is great danger in becoming too specific. Knowing that abstraction veils and conveys so much is not only helpful, it is essential. But heaven protect us from the endless boring and wrongheaded criticism that will proliferate when art critics and graduate students start telling us exactly how Miró, de Kooning, Hofmann, or Hartung felt when they painted each of their paintings!

What is it, then, that is of particular interest in the recent work of Hans Hartung? To me it is daring combined with absolute mastery; it is vigor and vitality.

Hartung dares and he succeeds. More clearly than ever before, in any given year, he works in several modes. The "long grasses" reappear in the top half of a painting (T 1973 E-12); clouds, beehives, shells, and combinations of these appear within single paintings. The forms within paintings are larger; the typical formats are 60⅝ by 98⁷/₁₆ inches and 43¹¹/₁₆ by 70⁷/₈ inches, not enormous by the standards of the New York School, but large in the context of Hartung's work. The size is in part determined by what he can comfortably manage as far as reach, stretch, and balance are concerned. It is possible that the paintings have increased in size and majesty for two reasons that reinforce each other: Hartung has come to command his content, and he has mastered his means to a point at which the arm stretched to its furthest in every direction is necessary to complete the mental gesture, the invention and extrapolation of his vision. This is the humanism in abstraction of Leonardo's Schematic Drawing of a Man of Perfect Proportions. The size of Hartung's paintings has increased since the mid-sixties and concurrently there has been a steady increase in the international appreciation of his art. Whether or not these two phenomena are linked is a matter of speculation. Yet, more and more, Hartung's paintings are appearing in public collections. Can this have escaped his notice? Ought it to? I do not say that Hartung is painting for museums, but rather that he is painting with an awareness that a significant number of his best works will be viewed in museums, and collected institutionally; and that this awareness has worked in tandem with the growing unity of his vision to produce the new work.

While the work of the thirties and fifties is strong and fresh, the drawing in the new paintings has become fused with the invented shapes. Fragmentation has led

to coherence, graphism to form-making. Even background and foreground, an important dichotomy in the earlier work of Hartung, and indeed in Surrealism in general, have merged into mass-making. Who can determine with any certainty where the planes lie in the central portion of T 1973 E-4? Or in T 1971 E-3, where the drawing and the form-making are so at one as to be indistinguishable, do the yellow at the right and the orange-red at the left lie in front of or behind the black at the center, a black echoed so effectively at the far right? Two areas of black in the same painting serve radically different purposes; they are in fact and in effect different blacks.

Hans Hartung's art has been growing more elegiac and magisterial through his recent work, in which full chords are powerfully orchestrated in resolutions of plastic problems previously only suggested. One is reminded of the late Brahms in mood, color, and the affirmation of life. Tragedy has been faced and fought and conquered. Tragedy and exhilaration have been fused. This is what Hans Hartung has dared to attempt in the paintings of recent years. It is my belief that he has succeeded triumphantly.

<div align="right">Henry Geldzahler</div>

1. Interview with Hans Hartung by François Le Targat in *Hans Hartung 1971–1974*, published by Arts et Métiers Graphiques and Galerie de France, Paris, 1974; third page of interview.

2. Roger Bordier, "L'Art et la manière: Hartung ou l'improvisation travaillée," *Art d'Aujourd'hui*, (March–April, 1954), p. 45.

3. Umbro Apollonio, *Hans Hartung* (Harry N. Abrams, Inc.; New York, 1966); seventh page of essay in which the pages are unnumbered. The quote is taken from Georges Charbonnier's interview with Hans Hartung in Georges Charbonnier, *Le monologue du peintre* (René Juillard; Paris, 1959), pp. 67–68.

4. Bordier, pp. 44–45.

5. Charbonnier, p. 67.

6. Charbonnier, p. 70.

7. Pierre Volboudt, "A chacun sa réalité," *XXe siècle*, (June, 1957), pp. 26–27.

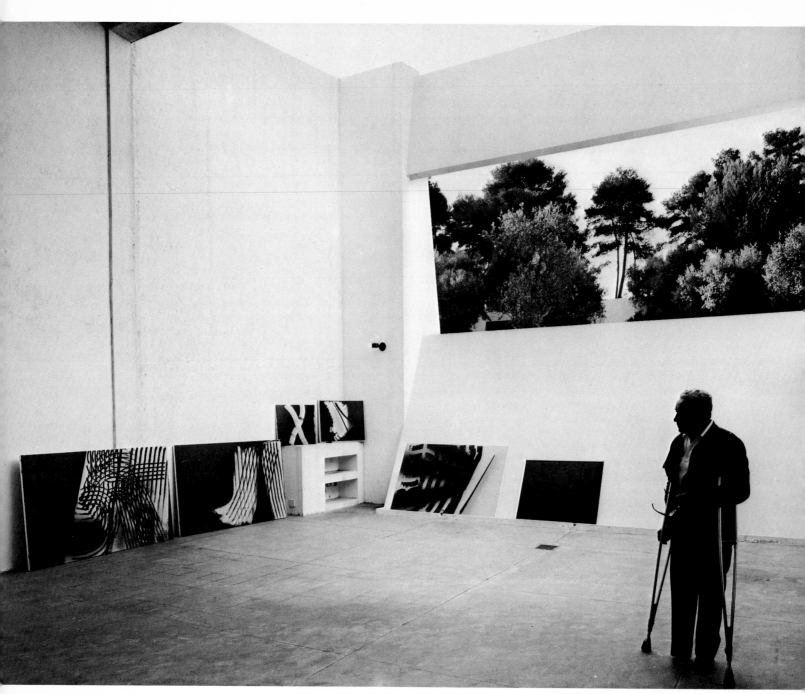

Hans Hartung in his studio, Antibes

Biographical Notes

<u>1904</u> Hans Heinrich Ernst Hartung born in Leipzig, September 21. His father and maternal grandfather were doctors. Both his maternal grandfather, a musician and self-taught painter, and his mother were passionate music lovers; this is without doubt the source of his sensitivity to music, especially Italian, French, and German music of the seventeenth and eighteenth centuries, and modern music.

<u>1912–14</u> The Hartung family moved to Basel. Astronomy and photography excited Hartung's imagination, and he made a telescope. The surrounding mountains left a lasting impression. With the outbreak of war in 1914, the family returned to Leipzig.

<u>1915–24</u> Studied at the Gymnasium in Dresden, earning a baccalaureate in Latin and Greek. Although attracted to the natural sciences and religion, Hartung decided to devote his life to painting. He was initially inspired by Rembrandt, Goya, Frans Hals, and El Greco; then in 1921 and 1922 he discovered Corinth, Slevogt, and the German Expressionists, in particular Kokoschka and Nolde. "…I was strongly inspired by Rembrandt. It was during a violently religious phase… that I came to him… His profound humanity touched me, as well as his ability to express with a simple line more than others with immense pictures. I also received an impetus from Slevogt, from the last works of Corinth, of Nolde, of Kokoschka, from the German Expressionists in general. Equally from Christian Rohlf… and from the woodcuts of Schmidt-Rottluff and Heckel."[1] During this time recognizable subject matter disappeared from his painting; Hartung progressed towards an abstraction characteristic of his mature works. He achieved this independently, unaware of the work that had already been done for approximately ten years by Kandinsky, Mondrian, and others. In 1922 he painted a series of abstract watercolors, which were to be the subject of a book by Will Grohmann in 1966. In 1923–24 he did a series of charcoal and crayon sketches.

<u>1924–25</u> Studied philosophy and art history at the University and the Academy of Fine Arts of Leipzig; attended a Kandinsky lecture in 1925—his first contact with abstract art. "In 1925, while listening to a talk by Kandinsky, I had noted that others were working in the same direction… I was still in doubt as to whether my approach was well-founded…, I made copies of Frans Hals, … Goya, …Rembrandt, …El Greco, …Picasso, …Matisse, …van Gogh, …It was only in 1933 that I… recommenced and continued working according to my own conception…."[2]

His professors advised him to study at the Bauhaus, but he preferred the Academies of Fine Arts of Dresden and of Munich, where he continued to study with Professors Feldbauer, Dorsch, Wehlte, and Doerner.

<u>1926</u> At the Dresden International Exhibition, Hartung discovered modern painting outside Germany, specifically French Impressionism, Fauvism, and Cubism. He was immediately interested in Rouault, Rousseau, and Picasso. He copied the work of Goya, Frans Hals, El Greco, Picasso, and Matisse in museums or from color reproductions. "In 1926 at the international exhibition of Dresden, I saw… French paintings, …works by van Gogh and Munch, which decided me to go to Paris… I wanted to study in depth everything which had happened during the last decades… to see if my 'informal' painting stood up and could be justified when compared."[3] During the summer he toured Italy by bicycle. In October he arrived in Paris; except for several trips, remained in France until 1931. Although he visited museums and exhibitions, and frequented private painting academies, he had no contacts with other painters during this time.

<u>1927–29</u> Hartung vacationed twice in the south of France, where he was confronted with the aesthetics of Cézanne and van Gogh, as well as Cubism; but these influences would not be evident in his work until 1932. This period was also spent working on the potential relationships—in the form of intervals, proportions, rhythms, and colors—between aesthetics and mathematics. Hartung made several study trips, notably to Holland and Belgium. In September, 1929, he married a young Norwegian painter, Anna-Eva Bergman, whom he met in Paris. "The precise date was May 9, 1929; we met at the… Académie Scandinave—Mapon House in Montparnasse, which had a dance hall. Some friends had taken us there because we both spoke German. I'd just arrived from Vienna. After that, we were hardly ever separated. We became engaged in Versailles, at the Château of Versailles, on May 25, 1929, that soon… We got married in a little Norwegian church, Kirchewang at Riesengebirge… on September 28, 1929. And the whole family came together, mine, Hans'; everybody was pleased. Then we went off for a long walking tour in the mountains for several weeks… We went to work at André Lhote's atelier. It was there that he got the reputation of being a bit cubist, but this was not at all true; it was Lhote who had that way of teaching his students. But all that amounted to maybe eight days or two weeks, or something like that… We spent the winter in Dresden, and it was rather interesting and frightening at the same time, because it was right in the middle of the pre-Hitler period, and there was unemployment and… misery and disaster everywhere… We saw the communists and the Hitler Youth

Group fighting on a street corner, and naively we giggled about it, thinking it was funny... Hans' father... said, 'Don't laugh, that may be the most serious thing that ever happened in Germany, the coming of these Hitler Youth Groups'..."[4]

1930–31 Hartung spent the winter on the Côte d'Azur. In November, 1931, the Heinrich Kühl Gallery in Dresden gave him his first exhibition. The art critic Will Grohmann had already taken an interest in his painting. "It was a little exhibition, but the first ones to take an interest were Will Grohmann, the greatest art historian in Germany, and Fritz Bienert, the greatest collector of Saxony. And that is how he saved his reputation a bit, that is, the collector bought the picture, and that's about all. He had some very good criticisms and later he had a contact with Flechtheim of Berlin, who took a great deal of interest in his pictures and sent a card which we still have, saying that Hans was much too expensive for such a young artist."[5]

1932 Hartung participated in the "Young Artists" exhibition at the Flechtheim Gallery in Berlin. His next exhibition, which included works by his wife, Anna-Eva Bergman, took place at the Blomquist Gallery in Oslo. "It was my academy professor who had organized that exhibition. I was very much on the naive side, but Hans made a big impression on the intellectuals. Sales weren't very good. For the most part, our own family bought things, whether to help us or to be kind, I don't really know. There was also a great Norwegian collector, who had nothing to do with me, who bought a big picture of Hans'. But it wasn't the sort of success that we could live on very long."[6] The sudden death of Hartung's father left him shaken and in poor health. "We rented a little fisherman's cottage... in southern Norway, and... stayed there for several months... work[ing]... fish[ing]... liv[ing] a life which was completely innocent and marvelous. On the day of Hans' birthday we got a message from the grocer in the little village across the way that there was a telegram for us. We thought it was... a telegram of good wishes on his birthday... We rowed over in our little boat. And there, someone on the telephone answered that he had a telegram announcing that Mr. Hartung was dead, and asking, 'What shall we do about the body?'... It was a terrible shock for Hans. His mother had already died in a brutal way. And ...later... the same thing was to happen with his sister, who was crushed to death by a truck. He was very ill for months. We were barely able to leave Homboröen to go to the funeral."[7] This, and the rise of Nazism, made him decide to leave Germany. While passing through Paris, he left several canvases at the Galerie Jeanne Bucher. He took refuge in the Balearic Islands (Minorca), where he built a small house near Fornells, a fishing port situated on the north side of Minorca. "We designed it together. I designed a lot, because I'd learned that in the school of applied arts, and Hans applied a whole aesthetic reasoning... as he always did. It was an excessively simple house... [with] neither running water nor electricity, no comforts and the roof wasn't even waterproof, but we had a terrace... and... for our water, a cistern when [it] was full, and otherwise from a farmer who came to deliver water to us from a well which had rats floating in it, which gave us paratyphoid fever."[8]

1933–34 For two years, Hartung worked assiduously and abandoned Cubism to return to a more independent style of painting. His canvases from 1932 to 1934 recall the ink drawings of 1922–23. With his funds sequestered in Germany: having run out of money, he left Minorca for Paris, and then went to Stockholm.

1935 Hartung returned to Berlin in hope of improving his financial situation. "We rented a studio at number 15 Budapeststrasse, and furnished it with some old furniture which had belonged to Hans' father. But we didn't stay there long because the Gestapo began to take a strange interest in our business. We were watched. The first suspicion came when Hans couldn't paint in Germany. He had to belong to the Cultural Chamber. To belong to the Cultural Chamber, he was obliged to become once again an 'inside' German, while we were then 'outside' Germans, and since he was very doubtful about becoming an 'inside' German, he didn't want to sign up. So he went to the Academy to learn to do frescos and perfect various techniques with Kurt Welte."[9] Finding himself under surveillance by the Nazi police, he decided to leave Germany; in October he escaped to France with the aid of Will Grohmann and Christian Zervos. "He contacted Will Grohmann, who was... anti-Nazi and a resistant.... Grohmann said, 'You're lucky, Christian Zervos... happens to be here, and if you get to Frankfort now, he may be able to help you get a visa for France, and a passport to leave Germany... We were obliged to leave Germany immediately... to go to Frankfort, then to Paris."[10] In Paris Hartung became the friend of Jean Hélion and Henri Goetz; met Kandinsky, Mondrian, Magnelli, Domela, Miró, and Calder. His first studio in Paris was at 19 rue Daguerre. "We stayed several months. My mother... took me forcefully to San Remo so I could recover after an operation. Hans stayed... and... found an apartment in the rue François Mouthon, where we could be together and things were much more comfortable."[11] From 1935 until the outbreak of war, he exhibited each year at the Salon des Surindépendants. "It was the only place he could exhibit, except on exceptional occasions such as at Pierre Loeb's.... He didn't sell a thing... All the geometric artists considered him a savage with his spots and his action painting, which was rather dramatic and virulent... He... got acquainted

with Mondrian... at a party given by my mother.... Mondrian asked, 'Can we dance? It's the only thing that interests me.' So we went dancing with him."[12] Between 1934 and 1938, Hartung painted a series of so-called "ink blot" canvases.

1936 Group exhibition in May at the Galerie Pierre with Kandinsky, Arp, Hélion, and the architect Nelson.

1937 Exhibited a huge canvas with black bars in the international exhibition organized by Christian Zervos at the Jeu de Paume. In this exhibition, Hartung saw and was impressed by sculptures by Julio Gonzalez.

1938 The Hartungs' financial situation became increasingly precarious. They moved and settled in a small studio on the rue de la Convention. Anna-Eva became extremely ill; she returned to Norway in mid-1938. A separation followed, and eventually a divorce. It was to be fourteen years before they were reunited. The German ambassador confiscated Hartung's passport, and for a year Henri Goetz extended him his hospitality. His paintings were shown in several galleries in London, notably the new Burlington Galleries' anti-Nazi exhibition "Twentieth Century Art." Hartung worked in the studio of Julio Gonzalez and tried his hand at sculpture.

1939 In the spring Hartung exhibited some pastels and drawings at the Galerie Henriette in Paris at the same time that Roberta Gonzalez, daughter of the sculptor, showed canvases. Through the intervention of Jean Hélion, the organizers of the first Salon des Réalités Nouvelles accepted a drawing by Hartung, but his name did not appear in the catalogue. Hartung volunteered to join the French army in the event of war. In July he married Roberta Gonzalez. In December he was mobilized, assigned to the Foreign Legion, and sent to North Africa for military training.

1940–41 Demobilized after the defeat, Hartung returned to France and lived with the Gonzalez family, who had taken refuge in the department of Lot.

1942–44 In March, 1942, Julio Gonzalez died suddenly. After the German occupation of France, Hartung fled to Spain, where he was imprisoned. Freed seven months later, he rejoined the French army in North Africa, and reenlisted in the Foreign Legion. In November, 1944, during the attack on Belfort he was seriously wounded and underwent the amputation of his leg.

1945–46 At the end of 1945, Hartung returned to Paris, and began to work again. Was made a French citizen as a result of his military record, and awarded the Croix de Guerre, the Médaille Militaire, and the Légion d'Honneur. Showed in

exhibitions at the Centre de Recherches, rue Cujas, with Domela and Schneider, and in group exhibitions at the Galerie Denise René, and the Galerie Colette Allendy. His work attracted the notice of several critics, among them Charles Estienne, Wilhelm Uhde, Madeleine Rousseau, and Léon Degand. He exhibited at the Salon des Surindépendants in 1945 and 1946 and again in 1962, at the Salon des Réalités Nouvelles from 1946 to 1950 and again in 1956, at the Salon de Mai from 1946 to 1961 and again in 1967. He also produced a series of engravings between 1946 and 1947.

1947 Hartung's first one-man show in Paris, on the occasion of the opening of the Galerie Lydia Conti. The canvases of 1947 to about 1951 were often characterized by a feeling of turmoil and revolt; afterwards, between 1952 and 1954, they became more static. Alain Resnais made a film about Hartung, which was presented in 1948 in Germany, and in 1950 at the La Hune Gallery/Bookstore in Paris. Hartung met critics, connoisseurs, sculptors, and painters, including Schneider, Soulages, Mathieu, Baumeister, Fritz Winter, and Rothko. "From the beginning of my career, in 1922, until the period after the war, I felt entirely isolated in my work. I was happy to find, after the war, artists who were devoted to the kind of painting that was my preoccupation. I had finally found colleagues, and several years later, at first with their visits and through personal contact, later at exhibitions of their work in France, I received the second tremendous confirmation of the art that I was fighting for, and I found this extremely comforting. On first seeing the work of Americans, after 1950, the enormous dimensions of the canvases astounded me and made me a little jealous of so fertile a milieu, in which it was possible to dare so successfully, and which was developing in a different direction than ours. The large paintings (as big as eighteen feet) by Pollock, Still, Newman and Kline were unthinkable to a European, and yet, it was exactly this aspect of the work, the dimension and the new scale, that came as a fresh breeze. These dimensions impressed me even more because during the war I lost a leg and painting huge pictures had become extremely difficult for me. Financial problems such as the size of my studio and the purchase of materials were lesser factors. At first I especially liked Kline and Pollock, and later, the marvelous work by Rothko, whom I believe to be a great artist and who became a friend, as Calder had been since 1935... I like very much, I might even say I have a special predilection for, Cornell and his boxes. Later I was fascinated by the cruel and penetrating aspect of Keinholz's work. Sam Francis and Oldenburg are also artists I like."[13]

1948 Exhibition at the Galerie Lydia Conti of early and recent drawings (1922–1948). Hartung's

work was included in a traveling exhibition of French abstract art in Germany (Stuttgart, Munich, Düsseldorf, Hannover, Frankfort, Wuppertal, Kassel). He also showed at the Venice Biennale. "In the past, when I had a great deal of difficulty getting hold of the materials that are indispensable for my work—an extremely disagreeable situation for a painter and one which lasted a long time in my case—I always did sketches first, lots and lots of them, until I chose the best of the lot. And then, I gave a lot of thought to what could strengthen it and improve it before risking one of my rare canvases. Later on, after the war, when I had enough money to buy almost as much material as I wanted, for two years I did nothing but pastels, etchings, and lithographs which I made absolutely without preparation, directly on the paper, the copper or the stone. Later still, once I was used to improvising, I worked directly on the canvas, without trial, no matter what its dimensions."[14]

1949 Domnick Verlag in Stuttgart published the first book about Hartung, with the text by Madeleine Rousseau, and the prefaces by James Johnson Sweeney and Ottomar Domnick. Hartung had a one-man exhibition of drawings at the Moderne Galerie Otto Stangl in Munich, and another at the Hanover Gallery in London.

1951 Exhibited pastels at the Galerie Louis Carré, along with Schneider and Lanskoy. One-man exhibition at the Galerie d'Art Moderne in Basel. Hartung's work was included in the exhibition "Advancing French Art" in New York, Chicago, Baltimore and San Francisco, and also in the exhibition "Véhémences confrontées" organized by Michel Tapié at the Galerie Nina Dausset.

1952 In February-March, Hartung had a retrospective exhibition at the Kunsthalle in Basel. Did a new series of engravings during the winter of 1952–53, and had a one-man exhibition at the Rudolf Probst Gallery in Mannheim. "I saw exhibitions of American painting in the years 1951–53, I believe, at the Galerie de France, the Galerie Fachetti, and the Galerie Maeght. The exhibition at the Galerie de France included, among others, Kline, Pollock and Motherwell... And I said to myself, 'We have infected them,' and they have acquired a taste for some of our ideas. I also saw an exhibition of paintings by Kline, somewhere on the Left Bank... They impressed me because from one painting to another I could see his working process; from a more or less expressionist figuration he progressed toward an abstraction pushed further and further along until, finally, the resulting paintings were tremendously enlarged details whose feeling and meaning were something totally different from their point of departure; they were extremely strong paintings."[15]

1953 One-man exhibitions at Lefevre Gallery in London and Marbach Gallery in Bern. Settled in a new studio on the rue Cels in Paris with his first wife, Anna-Eva Bergman, whom he remarried after his divorce from Roberta Gonzalez.

1954 Exhibited canvases, pastels, and engravings at the Palais des Beaux-Arts in Brussels, and engravings at La Hune. Participated in the Venice Biennale and in exhibitions at the Ecole de Paris and the Galerie Charpentier until 1958. From 1954 until 1959 a new element appeared in Hartung's painting: flexible and rapid brush strokes.

1955 Participated in the first exhibition "Documenta" at Kassel. Showed in Lucerne, Pittsburgh, Tokyo, São Paulo, as well as the Graphics Biennial at Ljubljana, where he showed again several times.

1956 Hartung received the Guggenheim [Museum] Prize for the Continental Europe/Africa selection, and was elected a member of the Art Academy of Berlin. Exhibited paintings at the Galerie de France; retrospective exhibition of drawings at the Galerie Craven in Paris.

1957 Began a third series of engravings, etchings, and lithographs, as well as a series of pastels, which he continued until 1961. The Kestner-Gesellschaft of Hanover exhibited paintings (1932–1956), drawings, watercolors (1921–1954), engravings and lithographs. This exhibition traveled to Stuttgart, Berlin, Hamburg, Cologne, and Nuremberg; in March and April, the Kleemann Galleries in New York held a one-man exhibition.

1958 The Galleria Il Segno in Rome exhibited Hartung's engravings. Did a new series of lithographs, and an exhibition of his lithographic work was held at La Hune. On June 28, the town of Siegen in Westphalia awarded Hartung the newly created Rubens prize. Participated in several other exhibitions: one-man shows at the Galerie de France (pastels), and the Moderne Galerie Otto Stangl; "From Impressionism to the Present" at the Musée National d'Art Moderne, Paris; "Orient-Occident" at the Musée Cernuschi; "What are the Origins of Non-Objective Art?" at the Galerie Rive Droite, Paris. "The Cuttoli Collection" at the Pavillon de Vendôme, Aix-en-Provence; the World's Fair in Brussels; "Fifty Years of Modern Art" at the Palais International des Beaux-Arts at the Pavillon de la France; "Artists of the School of Paris" with Léger, Matisse, Picasso, Miró, Laurens, Magnelli, Arp, Jacobsen, at the Musée de l'Art Wallon, Liège; "Non-Objective Art" at the Beyeler Gallery, Basel. Elected a corresponding member of the Bavarian Academy of Fine Arts in Munich.

1959 Built a new studio in the Parc Montsouris district of Paris. Retrospective exhibition at the Musée d'Antibes. Special exhibition, with Anna-

Eva Bergman, of pastels in Aix-en-Provence. Exhibitions at the Kleemann Galleries in New York, Galleria La Bussola in Turin, and Moderne Galerie Otto Stangl. Shown in "Documenta II" in Kassel, "Contemporary Painting in France and Italy" in Turin, and at the inaugural exhibition of the Galleria d'Arte Moderna in Turin.

1960 The Grand International Prize for Painting of the Venice Biennale was unanimously awarded by the jury to Hartung. A room of the Pavillon de la France was devoted to his work. One-man exhibitions of pastels were held at the Galerie Van de Loo in Essen, and the Gimpel Fils Gallery in London. Participated in the exhibition "Antagonisms" at the Musée des Arts Décoratifs in Paris, and "Contemporary French Painting," which traveled to several museums in Israel. R.V. Gindertael published a monograph on Hartung. He was also made an Officer of Arts and Letters.

1961 Hartung entered a new phase in his art, in which he scored the paint while it was still wet. Retrospective exhibition at the Galerie de France; one-man exhibitions at the Galleria Lorenzelli, Milan (pastels); the Libreria Einaudi, Rome; the Ateneo, Madrid; the Galería Liceo, Cordoba; the Contemporary Art Center, Beirut. Participated in an exhibition of French art in Moscow, and in the exhibition "Paris: The Crossroads of Painting, 1945–1961" at the Stedelijk Museum in Eindhoven.

1962 Exhibition of recent canvases at the Galerie de France. Represented in an exhibition of French drawings, watercolors, and gouaches in Warsaw; "The School of Paris" at the Tate Gallery in London; "The Galerie de France in London" at the Redfern Gallery; and "Collection of the French Style" at the Musée des Arts Décoratifs, Paris.

1963 Executed a new series of lithographs at St. Gallen in Switzerland. His retrospective exhibition of canvases, drawings, pastels, and sculpture traveled to the Kunsthaus, Zurich; the Museum des 20. Jahrhunderts, Vienna; the Kunsthalle, Dusseldorf; the Palais des Beaux-Arts, Brussels; the Stedelijk Museum, Amsterdam. Had one-man exhibitions of recent canvases at Galerie Im Erker at St. Gallen, and the Galerie Günther Franke in Munich. Participated in the exhibition "The Art of Writing" at Baden-Baden and Amsterdam; "Exhibition of French Art" in Montreal and Quebec; "Contemporary French Paintings" in Salisbury, Capetown, and Johannesburg; "Artists of Paris" at the Galleria Hausamann, Cortina d'Ampezzo, where he also participated in the exhibition "8" in 1965; "The Dunn International" in Fredericton, New Brunswick; and in an exhibition at the Tate Gallery.

1964 During the summer, Hartung and Anna-Eva Bergman sailed along the Norwegian coast past the North Cape to the Soviet frontier, a trip from which they brought back nearly a thousand photographs. For some years, Hartung indulged his passion for photography, dating from his early youth, especially on trips to Spain, Japan, New York and Pittsburgh. In Pittsburgh, he was invited to judge an exhibition at the Carnegie Institute. This was his first visit to the United States. The Galerie de France showed fifteen recent paintings, and Hartung participated in the exhibitions "54/64: Paintings and Sculpture of a Decade" at the Tate Gallery, "Documenta III" in Kassel, and "Six Paris Painters" (Barbarigo, Bergman, Gischia, Hartung, Music, and Pulga) in Wolfsburg and Nuremberg. Received the Grand Cross of the Order of Merit from the Federal Republic of Germany.

1965 To coincide with the publication of a catalogue of graphic work (1921–1965), edited by the Rolf Schmücking Gallery at Braunschweig, an exhibition of Hartung's entire graphic output was held in the Städtisches Museum. His lithographs and engravings were exhibited at the Associated American Artists Gallery in New York, and at the University of Pittsburgh. An exhibition of his work opened the new Holst Halvorsen Gallery in Oslo. Participated in the exhibitions "A Century of French Art: 1840–1940" in Lisbon; "Traum-Zeichen-Raum" at the Wallraf-Richartz Museum, Cologne; and "Painting Without a Brush" at the Institute of Contemporary Art, Boston.

1966 During the period 1962–67, Hartung's canvases began to show a treatment of the surface with dark stains, and little or no graphic elements. "It is absolutely necessary, when one 'dives in,' to be ready to swim. Most of the time I know pretty nearly what I want to do in advance, something with a red or a cold yellow background, something light or dark, vertical, horizontal or diagonal. The colors are already prepared, or there may already be a first layer on the canvas. It is thoroughly dry, everything is ready. Then I sit down facing this surface, and I don't know what I am going to do. I have to decide instantly what it is to be. Work is short but very concentrated. I am forced to work fast because of the speed of my mental process and because of the limitations imposed on me by the material utilized. When I am working, I like to listen, uninterruptedly, to the music of Bach, Corelli and Vivaldi. Beethoven or Schumann require too much concentration. In their case, one must take into account their tormented souls, share their emotions. The earlier music forms a protective cloak and stands between me and the people around me, and the world in general. For this same reason I like to work in the evening; when it is dark, one is isolated."[16] *Hans Hartung: Aquarelle, 1922* published by Will Grohmann; this monograph was presented by the Galerie Im Erker in St. Gallen at the same

time that Hartung was in St. Gallen working on a new set of lithographs. One-man shows at the Sala Nebli, Madrid; the Galería René Metras, Barcelona; and the Galleria Stendhal, Milan. Retrospective exhibition of some two hundred works at the Galleria d'Arte Moderna in Turin. Exhibited new paintings at the André Emmerich Gallery, New York; this provided the occasion for his second visit to the United States. Traveled to Japan to take part in the International Symposium on Fine Arts in the East and the West organized by UNESCO. Umbro Apollonio's monograph on Hartung was published in Milan.

1967 One-man exhibitions at the Galleria La Polena in Genoa, and the Galleria d'Arte Narciso in Turin. Showed with Arp, Magnelli, and Anna-Eva Bergman at the Musée de Saint-Paul-de-Vence. Participated in the world's fair "Expo '67" in Montreal, where he was represented in the French Pavilion and the Pavilion of the European Community. Participated also in the exhibition "Ten Years of Contemporary Art, 1955–65" at the Maeght Foundation in Saint-Paul-de-Vence. The international jury of the Seventh Graphic Biennale at Ljubljana awarded Hartung the Prix d'Honneur. Showed in the 1967 Tokyo Biennial: the exhibition "Trends in Contemporary French Painting" at the Théâtre de l'Est Parisien, the Kunstverein, Berlin, and the Kunsthaus, Hamburg; the Pittsburgh International Exhibition; the exhibition "Rosc 67" in Dublin; the International Exhibition of Drawings at the Kunstverein, Hamburg; "German Drawings and Watercolors of the Last Twenty Years," also at the Kunstverein. Hartung was elevated to the rank of Commander of the Order of Arts and Letters.

1968 Retrospective exhibition at the Birmingham City Museum and Art Gallery. Participated in the traveling exhibition "Painting in France, 1900–1967" at the National Gallery, Washington, D.C.; the Metropolitan Museum of Art, New York; the Museum of Fine Arts, Boston; the Art Institute, Chicago; the Palace of the Legion of Honor, San Francisco. His work was included in the "Montreal II in Central Europe", and "Contemporary Art 1965–1968" at the Maeght Foundation, Saint-Paul-de-Vence. Hartung was elevated to the rank of Commander of the Legion of Honor.

1969 The Musée National d'Art Moderne, Paris, mounted a retrospective exhibition of more than 250 works, which later traveled to the Museum of Fine Arts, Houston: the Museum of Québec, and the Museum of Contemporary Art, Montreal. One-man shows at the Galerie Veranneman in Brussels (paintings) and the Galerie de France (paintings on paper). Represented at the Eighth International Engravings Exhibition in Ljubljana, the Il Collezionista d'Arte Contemporanea in Rome (paintings, drawings, and lithographs), and

the Kunstverein in Braunschweig (paintings, pastel drawings, engravings, lithographs).

1970 One-man exhibitions at Il Cancello, Bologna (lithographs); the Galleria Meneghini, Venice; the Galleria Bergamini, Milan; the Galerie Protée, Toulouse. Hartung was awarded the Grand Prix des Beaux-Arts de la Ville de Paris. (Mark Rothko died in 1970; Hartung reminisced about his relationship with the artist: "After the war, about 1948–49, in any case before 1950, several American painters—Rothko and Motherwell among them—came to visit me in my studio in Arcueil; I especially remember the visits of Rothko, who came several times and who saw a painting in progress, in which large horizontal monochrome strips crossed the canvas; the painting was at an intermediate stage and I had not yet added the graphic elements. Rothko was especially interested and moved… Rothko's death saddened me deeply and, I am happy to have seen, in his studio, his paintings for the chapel in Houston which were almost finished. I have been told that the chapel is completed and I think it must be a place where religious feeling has found its purest expression."[17])

1971 One-man exhibitions at the Lefebre Gallery, New York; the Galería René Metras, Barcelona; the Maeght Foundation, Saint-Paul-de-Vence (large-scale paintings); the Galerie de France.

1972 One-man exhibitions at the Galería Egam, Madrid (etchings); the Maison des Arts et Loisirs, Sochaux (paintings, engravings, lithographs); the Städtische Galerie, Siegen (graphics); the Kunstverein, Mannheim (graphics, 1921–1970); the Gimpel Fils Gallery, London (paintings, 1967–1971); the Karl Vonderbank Graphic Arts Gallery, Frankfort; the Galleria d'Arte Moderna Ravagnan, Venice; the Maison de la Culture, Rennes (lithographs); the Galerie Condillac, Bordeaux (paintings).

1973 One-man exhibitions at the Galerie Protée, Toulouse (paintings on paper, prints); Galleria Meneghini, Venice; the Galerie Maeght, Zurich; Galerie Jacques Benador, Geneva (paintings on cardboard); Galerie Noella Gest, Saint-Rémy-de-Provence (paintings and engravings); Galerie Kriwin, Brussels (paintings).

1974 One-man exhibitions at the Galerie de France ("Recent Works"); the A.B.C.D. Gallery, Paris ("Panorama of Graphic Works"); the Wallraf-Richartz-Museum, Cologne ("Retrospective on the Occasion of Hartung's 70th Birthday, and the 150th Anniversary of the Founding of the Museum"); the Galerie der Spiegel, Cologne (paintings on cardboard, lithographs); the Galerie du Fleuve, Bordeaux ("Lithographs of Hans Hartung"); the Galleria d'Arte Moderna, Turin.

1975 One-man exhibitions at the Galerie Arnaud, Paris ("Survey of Hans Hartung"); the Nationalgalerie, Berlin (the retrospective that was presented in Cologne in 1974); La Hune (prints and photographs exhibited on the occasion of the presentation of the work *An Unnoticed World Seen by Hans Hartung,* poems and tales by Jean Tardieu, reproductions of photographs by Hans Hartung, published by Albert Skira); the Govaerts-Hilton Gallery, Brussels ("Survey of Works by Hans Hartung"); the Glemminge Gallery, Glemmingbro, Sweden (prints); the Stadtische Gallery, Munich (retrospective); the Galerie Otto Stangl, Munich (graphic works and paintings); the Galerie Biedermann, Munich (books and graphic works); the Maison d'Art Alsacienne, Mulhouse (prints and drawings); the Galerie l'Œil 2000, Châteauroux (graphic works); Hôtel de Ville, Saint-Maximin-la-Sainte-Baume (prints and paintings on cardboard); Maison des Arts et Loisirs, Luxeuil ("Survey of the Graphic Works of Hans Hartung").

"I could very well one day return to doing my old spots or my earlier signs. One must never forbid oneself anything. One must also be able to go back, one must always be able to change. The outer world tries to put a label on people and, especially, on the artist: classicism, romanticism, humanism, anarchism, figuration, abstraction, geometrics. You're hunted out, and there is a single goal: to enclose you in a box. The first and most important thing is to remain free, free in each line you undertake, in your ideas and in your political action, in your moral conduct. The artist especially must remain free from all outer constraint. Everything we feel deeply must be expressed. What concerns me is more the law than the object. What fascinates me is to see on canvas or paper at least part of the immutable and complex laws which govern the world, laws that bring about the vibration of the electrons and other parts of the atom, that combine to form matter, traverse the cosmos, form worlds, create light, heat, and even consciousness and intelligence; those laws without which nothing exists. In my youth I wanted to become an astronomer and even now there remains, alongside the personal psychic life which tends to express itself, that desire to approach or at least sense this absoluteness of laws, those laws which interminably create the world of order which is behind everything."[18]

1. Heidi Bürklin, "Conversation with Hans Hartung," *Cimaise* (Sept.–Oct.–Nov.–Dec., 1974), pp. 16–17.
2. Bürklin, pp. 17–18.
3. Bürklin, p. 17.
4. Julien Clay, "Interview with Anna-Eva Bergman," *Cimaise* (Sept.–Oct.–Nov.–Dec., 1974), pp. 82–84.
5. Clay, p. 84.
6. Clay, p. 85.
7. Clay, p. 86.
8. Clay, p. 87.
9. Clay, p. 92.
10. Clay, pp. 93–94.
11. Clay, p. 94.
12. Clay, p. 95.
13. Unpublished answers to questions posed by Henry Geldzahler to Hans Hartung (July, 1975) concerning the artist's contact with contemporary art in the United States.
14. Bürklin, pp. 19–20.
15. Geldzahler interview.
16. Bürklin, pp. 20–22, 24.
17. Geldzahler interview.
18. Bürklin, pp. 24–25.

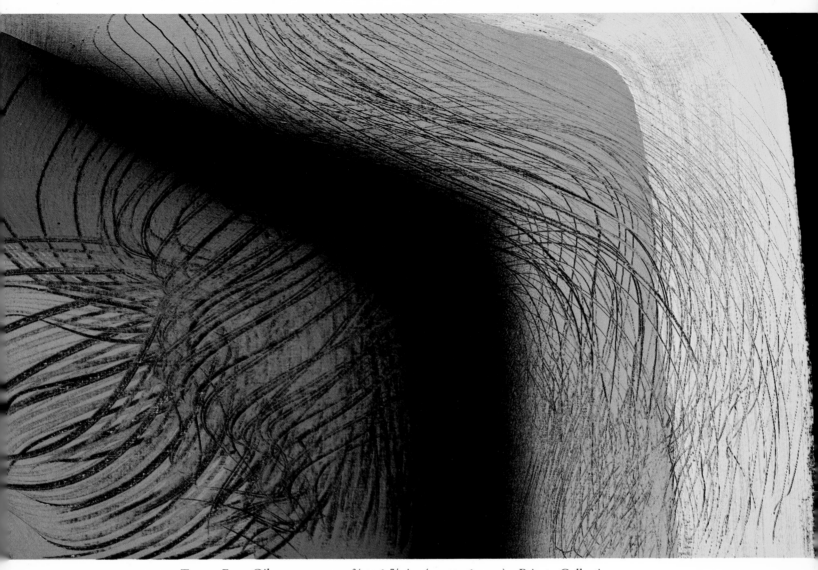

T 1971 E-3 Oil on canvas 39⅜ × 63⅞ in. (100 × 162 cm.) Private Collection

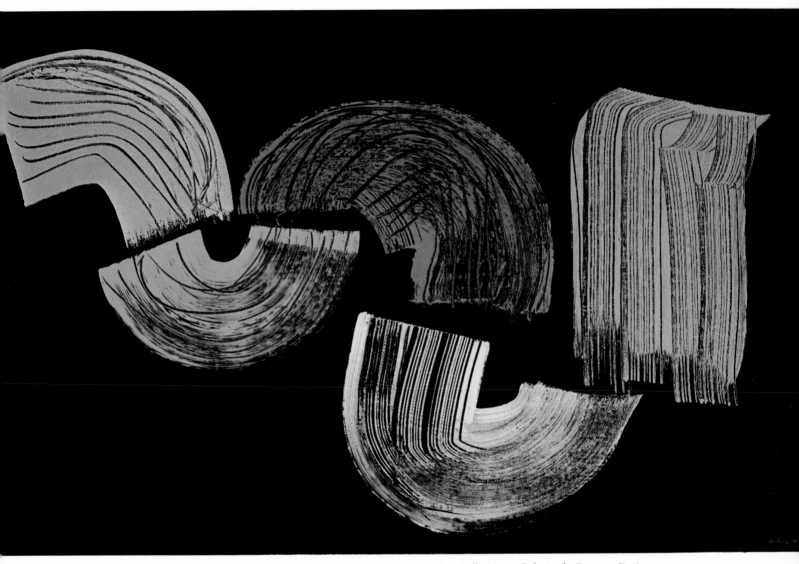

T 1971 E-5 Oil on canvas 39⅜ × 63⅞ in. (100 × 162 cm.) Collection: Galerie de France, Paris

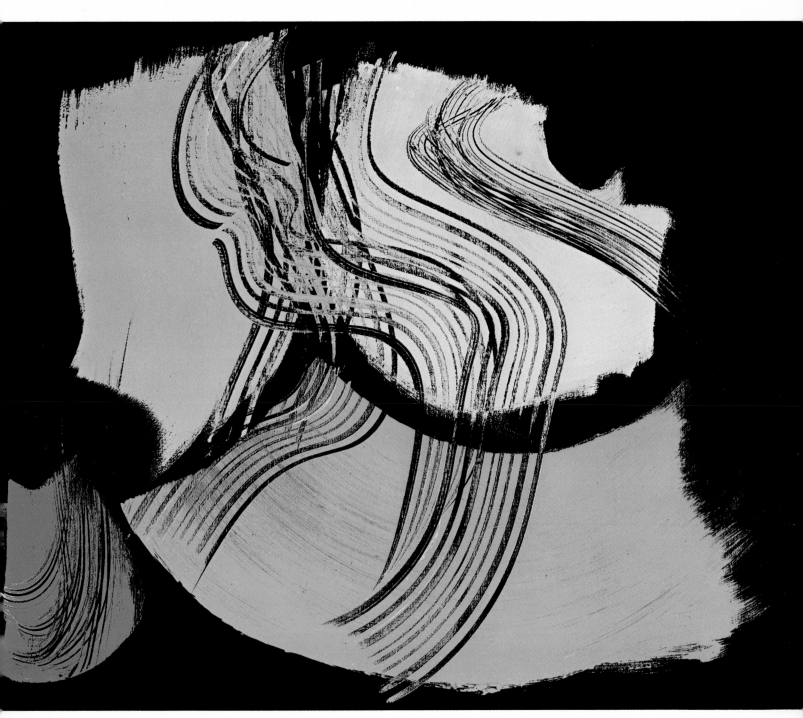

T 1971 E-29 Oil on canvas 40⅛ × 51¼ in. (102 × 130 cm.) Collection of the Artist

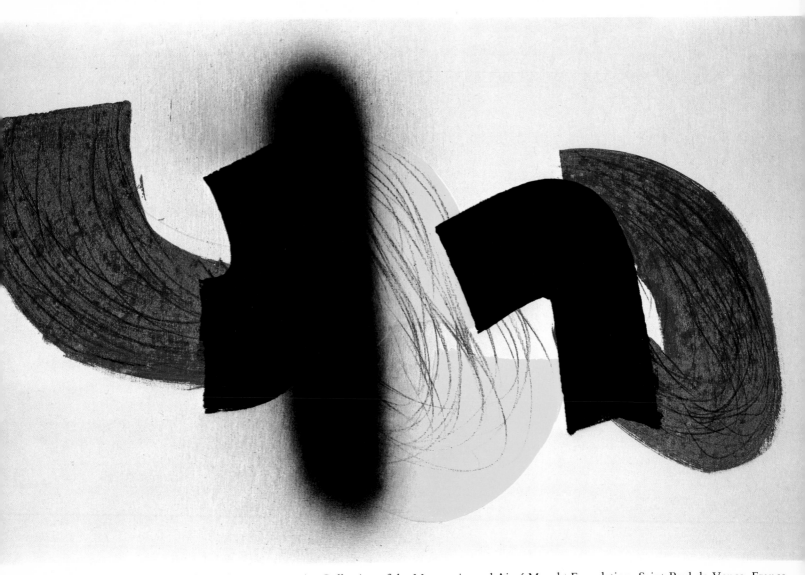

71 H-13 Oil on canvas 60⅝ × 98⁷/₁₆ in. (154 × 250 cm.) Collection of the Marguerite and Aimé Maeght Foundation, Saint Paul de Vence, France

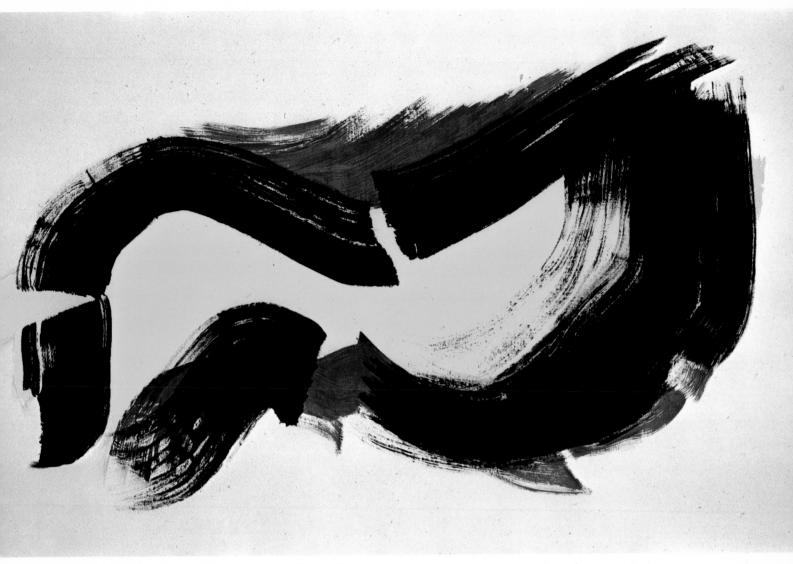

<u>T 1971 H-19</u> Oil on canvas 60⅝ × 98⁷/₁₆ in. (154 × 250 cm.) Collection: Galerie de France, Paris

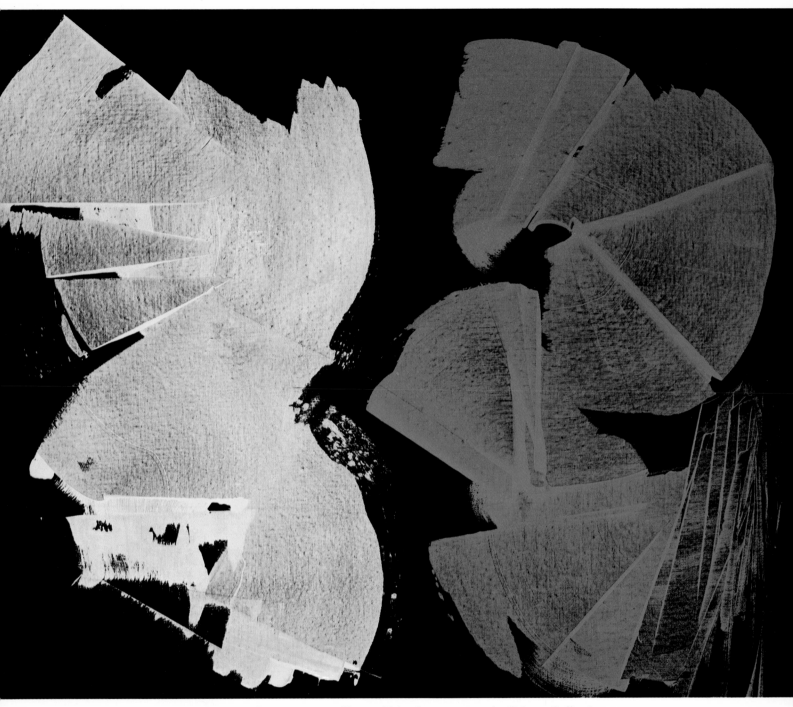

T 1971 R-12 Oil on canvas 44⁷/₈ × 57½ in. (114 × 146 cm.) Private Collection

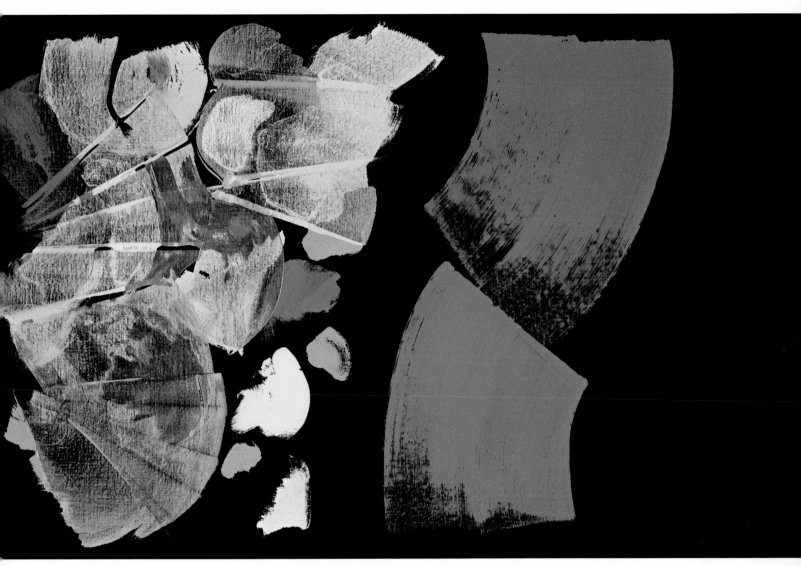

T 1971 R-15 Oil on canvas 43^{11}/$_{16}$ × 70^{7}/$_{8}$ in. (111 × 180 cm.) Private Collection

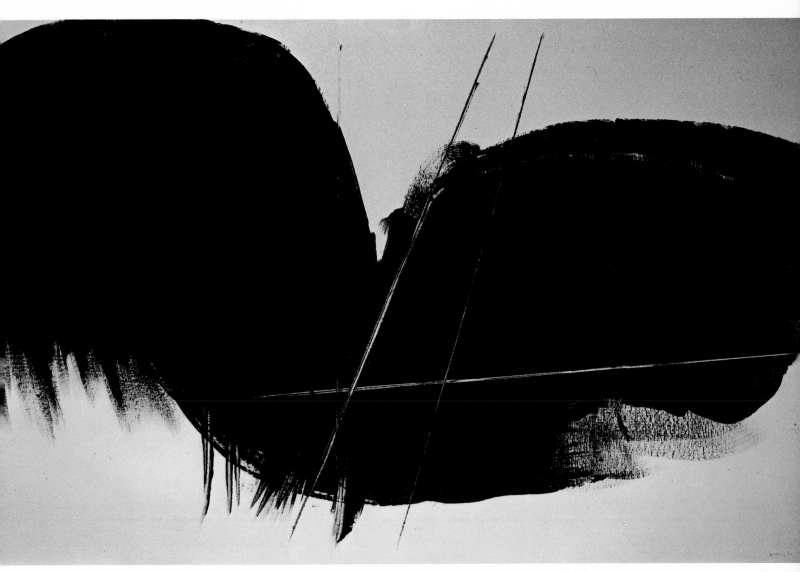

T 1971 R-29 Oil on canvas 60⅝ × 98⁷/₁₆ in. (154 × 250 cm.) Private Collection

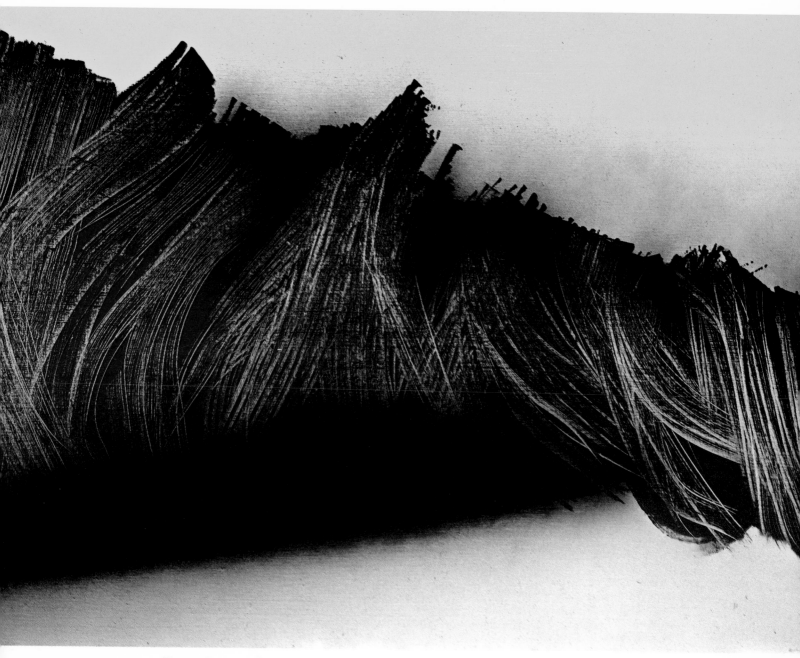

T 1971 R-30 Oil on canvas 70⁷/₈ × 98⁷/₁₆ in. (180 × 250 cm.) Private Collection

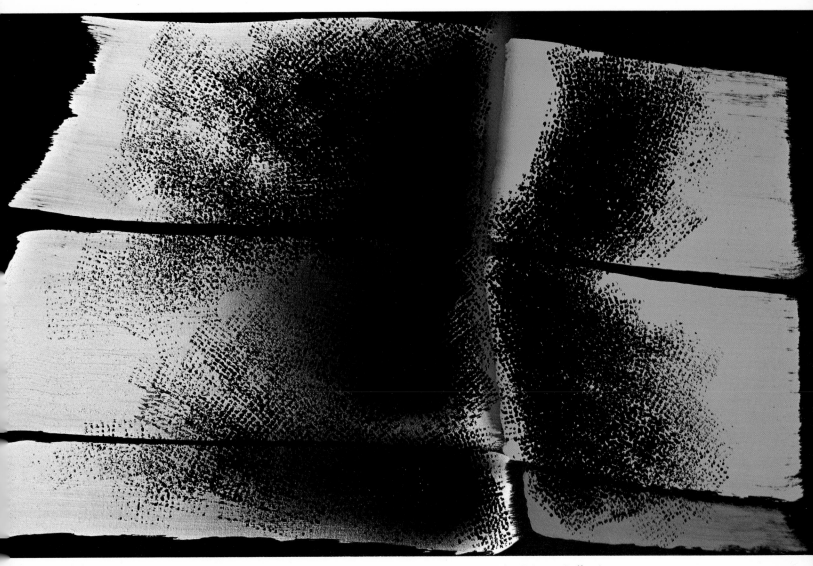

T 1973 E-3 Oil on canvas 43^{11}/$_{16}$ × 70^{7}/$_{8}$ in. (111 × 180 cm.) Private Collection

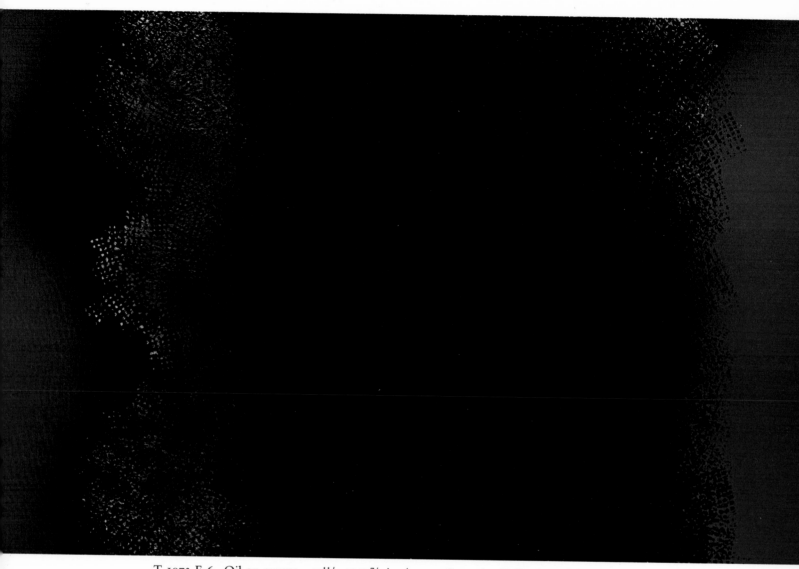

T 1973 E-6 Oil on canvas $43^{11}/_{16} \times 70^{7}/_{8}$ in. (111 × 180 cm.) Collection of the Artist

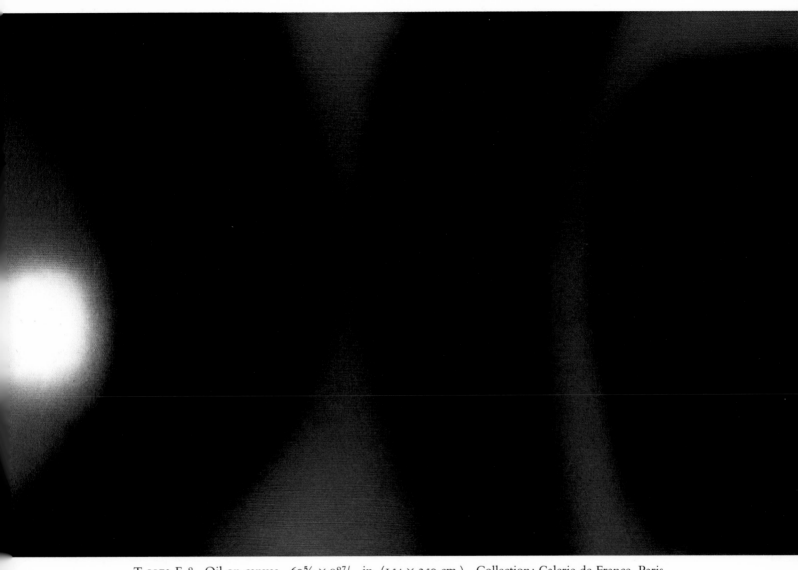

T 1973 E-8 Oil on canvas 60⅝ × 98⁷/₁₆ in. (154 × 250 cm.) Collection: Galerie de France, Paris

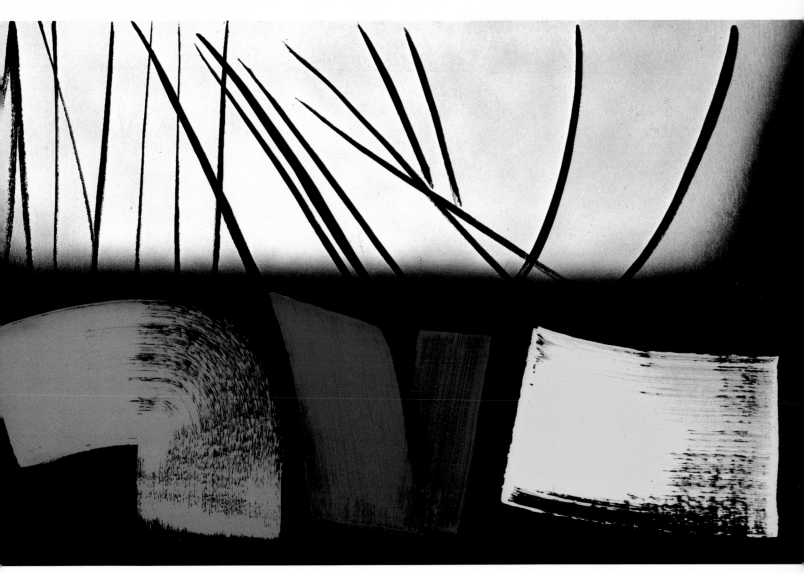

T 1973 E-12 Oil on canvas 60⅝ × 98⁷/₁₆ in. (154 × 250 cm.) Collection of the Artist

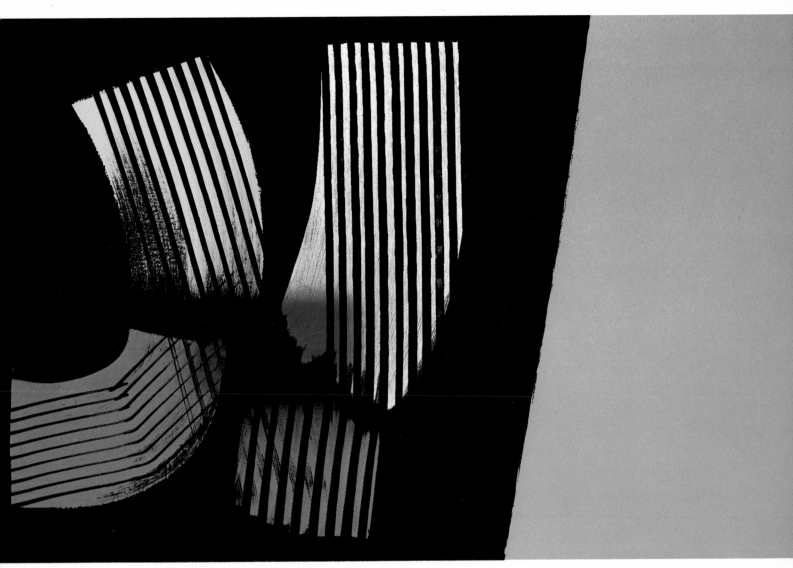

T 1973 R-13 Oil on canvas 60⅝ × 98⁷/₁₆ in. (154 × 250 cm.) Collection of the Artist

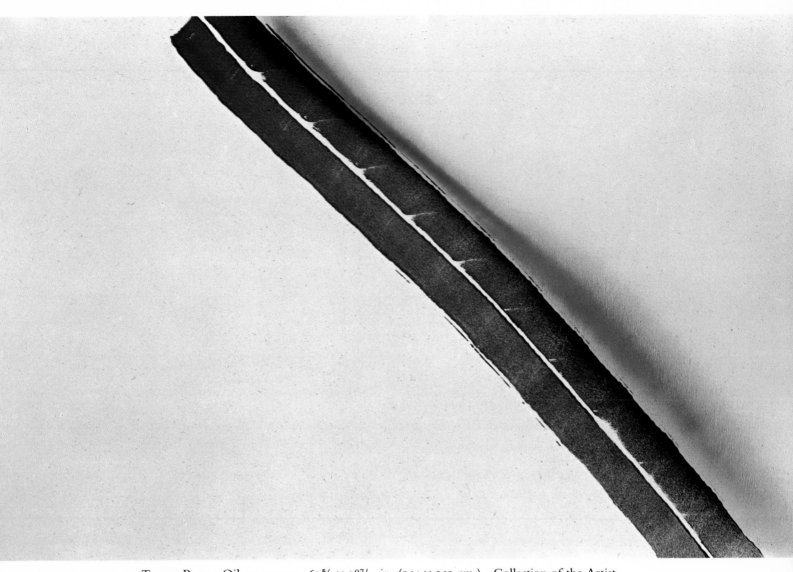

T 1973 R-14 Oil on canvas 60⅝ × 98⁷/₁₆ in. (154 × 250 cm.) Collection of the Artist

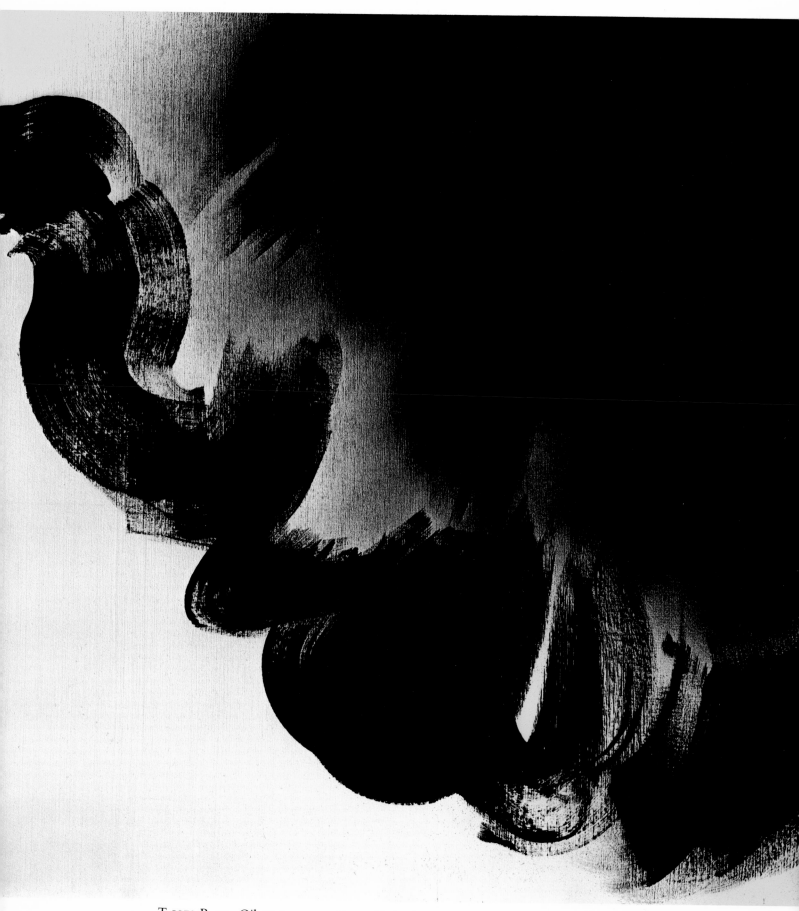

<u>T 1973 R-27</u> Oil on canvas 70⁷/₈ × 70⁷/₈ in. (180 × 180 cm.) Private Collection

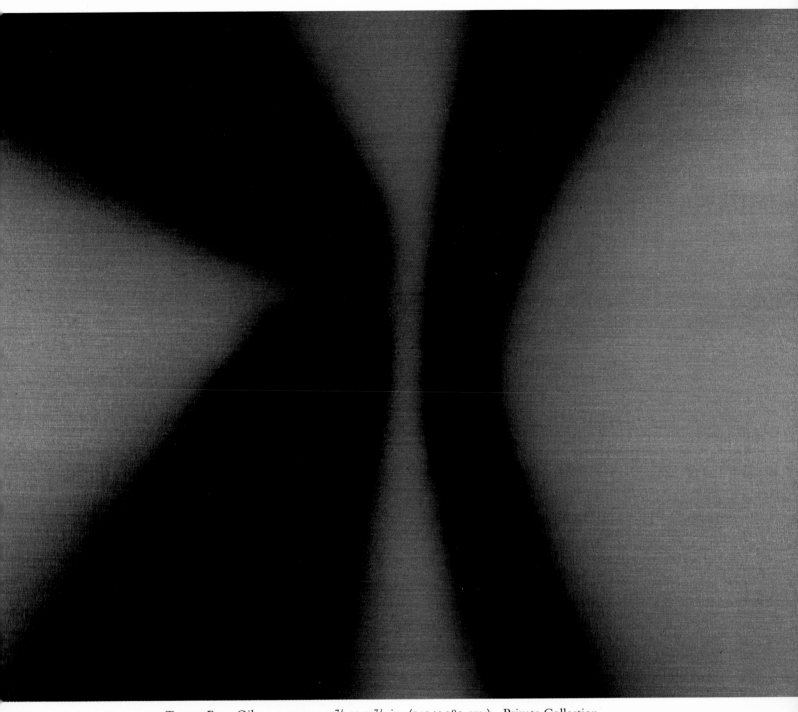

T 1974 E-9 Oil on canvas $55^7/_8 \times 70^7/_8$ in. (142×180 cm.) Private Collection

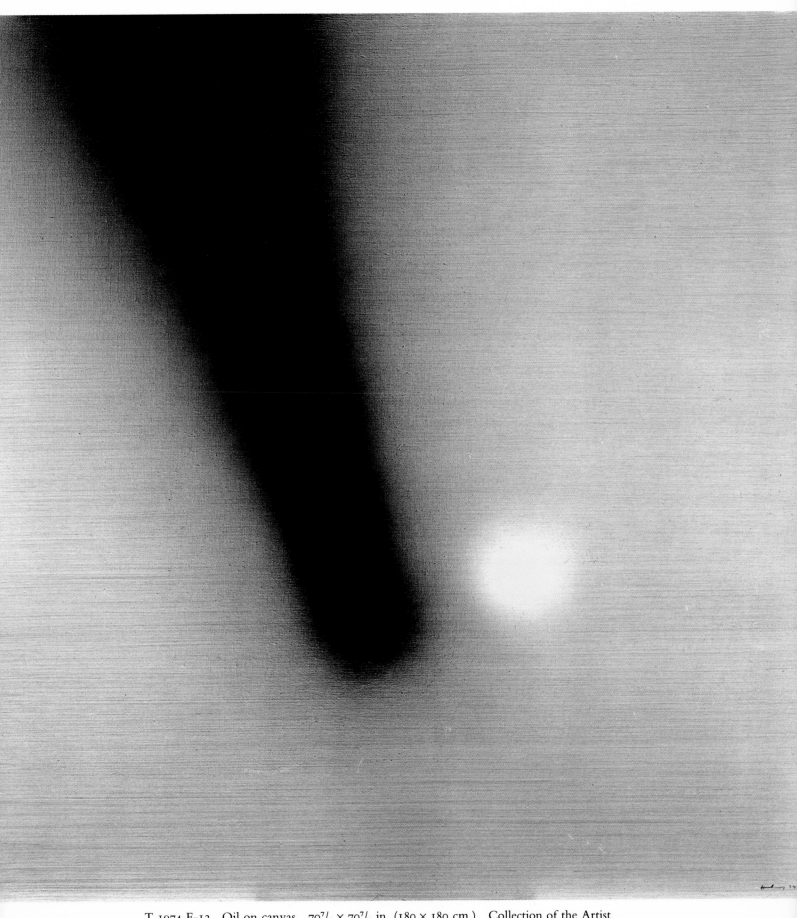

<u>T 1974 E-12</u> Oil on canvas 70$^7/_8$ × 70$^7/_8$ in. (180 × 180 cm.) Collection of the Artist

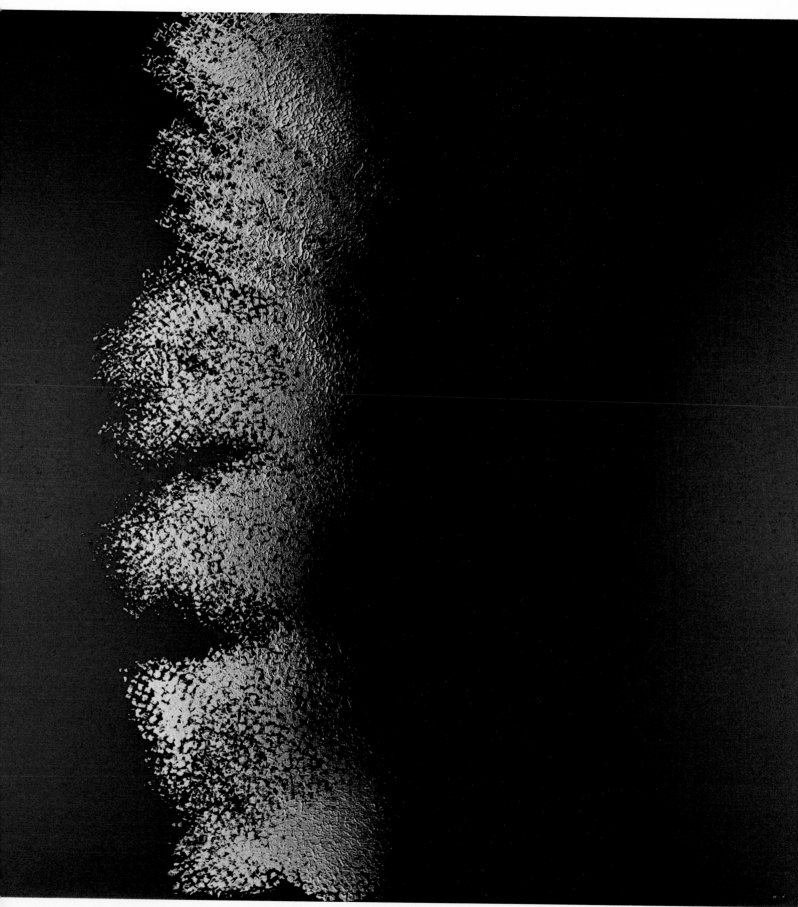

<u>T 1974 E-44</u> Oil on canvas 70⁷/₈ × 70⁷/₈ in. (180 × 180 cm.) Collection: Galerie de France, Paris

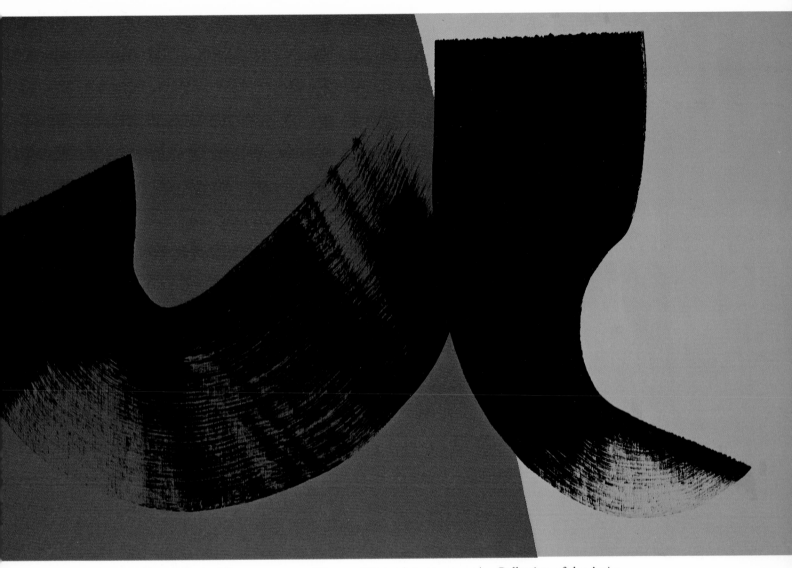

T 1974 R-1 Oil on canvas 72^{13}/$_{16}$ × 118^{1}/$_{8}$ in. (185 × 300 cm.) Collection of the Artist

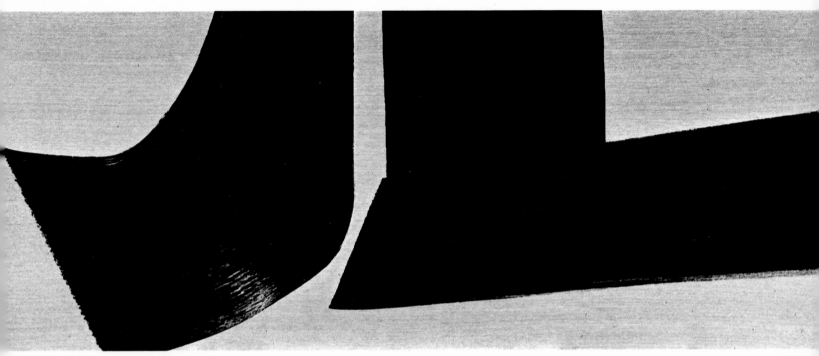

T 1974 R-2 Oil on canvas 44⁷/₈ × 118⅛ in. (114 × 300 cm.) Collection of the Artist

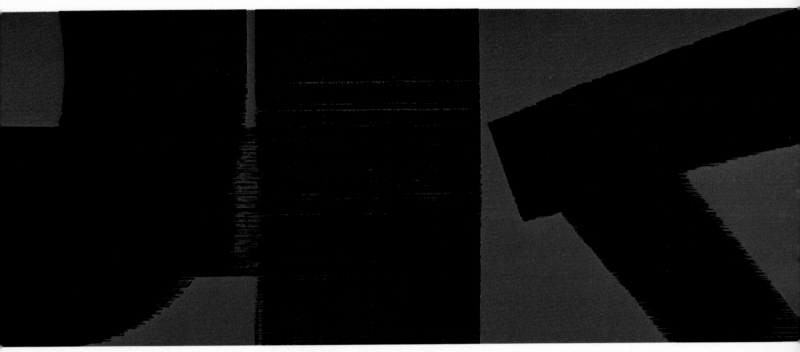

T 1974 R-21 Oil on canvas 44⁷/₈ × 118¹/₈ in. (114 × 300 cm.) Collection of the Artist

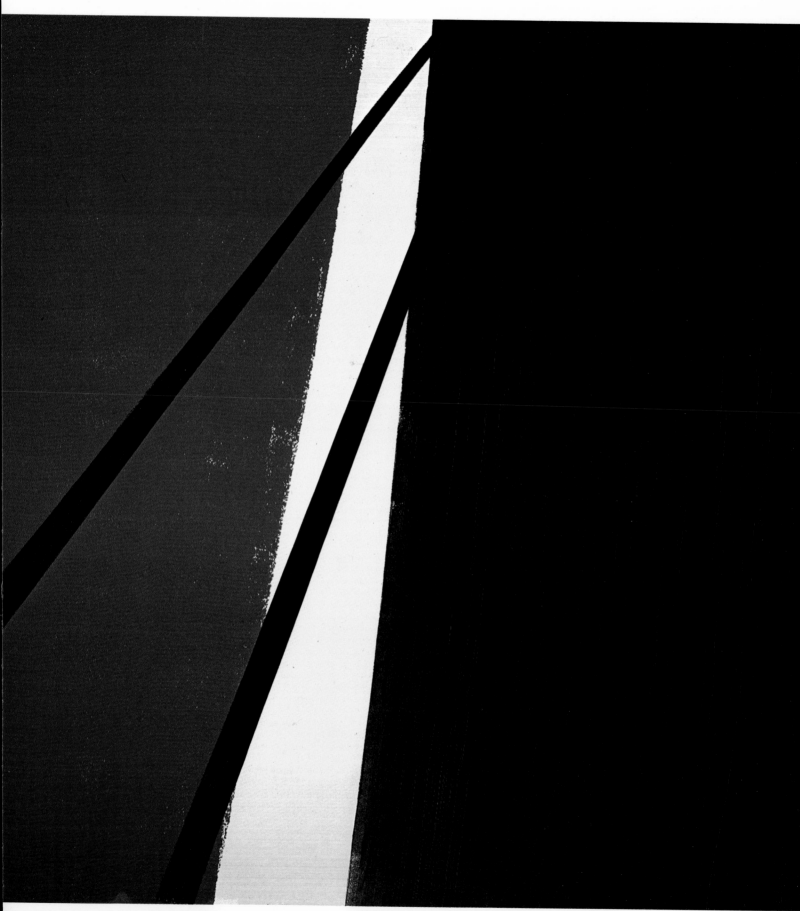

T 1974 R-23 Oil on canvas 70⁷/₈ × 70⁷/₈ in. (180 × 180 cm.) Collection of the Artist

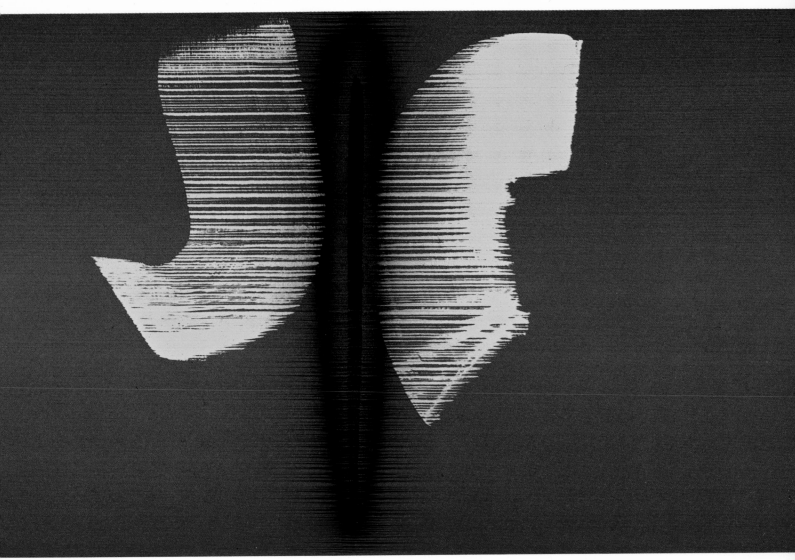

T 1974 R-24 Oil on canvas 43^{11}/$_{16}$ × 70^{7}/$_{8}$ in. (111 × 180 cm.) Private Collection

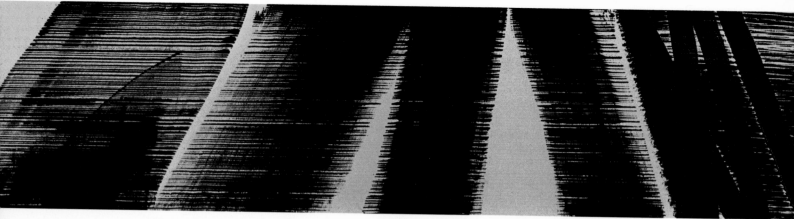

T 1974 R-33 Oil on canvas 27^{15}/$_{16}$ × 118$\frac{1}{8}$ in. (71 × 300 cm.) Collection of the Artist

T 1975 E-20 Oil on canvas 44⁷/₈ × 63⁷/₈ in. (114 × 162 cm.) Collection of the Artist

T 1975 R-35 Oil on canvas 70⁷/₈ × 70⁷/₈ in. (180 × 180 cm.) Collection of the Artist

List of the Works

T 1971 E-3 Oil on canvas
39⅜ × 63⅞ in. (100 × 162 cm.) Private
Collection

T 1971 E-5 Oil on canvas
39⅜ × 63⅞ in. (100 × 162 cm.) Collection:
Galerie de France, Paris

T 1971 E-29 Oil on canvas
40⅛ × 51¼ in. (102 × 130 cm.) Collection of the
Artist

T 1971 H-13 Oil on canvas
60⅝ × 98⁷/₁₆ in. (154 × 250 cm.) Collection of
the Marguerite and Aimé Maeght Foundation,
Saint Paul de Vence, France

T 1971 H-19 Oil on canvas
60⅝ × 98⁷/₁₆ in. (154 × 250 cm.) Collection:
Galerie de France, Paris

T 1971 R-12 Oil on canvas
44⅞ × 57½ in. (114 × 146 cm.) Private
Collection

T 1971 R-15 Oil on canvas
43¹¹/₁₆ × 70⅞ in. (111 × 180 cm.) Private
Collection

T 1971 R-29 Oil on canvas
60⅝ × 98⁷/₁₆ in. (154 × 250 cm.) Private
Collection

T 1971 R-30 Oil on canvas
70⅞ × 98⁷/₁₆ in. (180 × 250 cm.) Private
Collection

T 1973 E-3 Oil on canvas
43¹¹/₁₆ × 70⅞ in. (111 × 180 cm.) Private
Collection

T 1973 E-6 Oil on canvas
43¹¹/₁₆ × 70⅞ in. (111 × 180 cm.) Collection of
the Artist

T 1973 E-8 Oil on canvas
60⅝ × 98⁷/₁₆ in. (154 × 250 cm.) Collection:
Galerie de France, Paris

T 1973 E-12 Oil on canvas
60⅝ × 98⁷/₁₆ in. (154 × 250 cm.) Collection of
the Artist

T 1973 R-13 Oil on canvas
60⅝ × 98⁷/₁₆ in. (154 × 250 cm.) Collection of
the Artist

T 1973 R-14 Oil on canvas
60⅝ × 98⁷/₁₆ in. (154 × 250 cm.) Collection of
the Artist

T 1973 R-27 Oil on canvas
70⅞ × 70⅞ in. (180 × 180 cm.) Private
Collection

T 1974 E-9 Oil on canvas
55⅞ × 70⅞ in. (142 × 180 cm.) Private
Collection

T 1974 E-12 Oil on canvas
70⅞ × 70⅞ in. (180 × 180 cm.) Collection of
the Artist

T 1974 E-44 Oil on canvas
70⅞ × 70⅞ in. (180 × 180 cm.) Collection:
Galerie de France, Paris

T 1974 R-1 Oil on canvas
72¹³/₁₆ × 118⅛ in. (185 × 300 cm.) Collection
of the Artist

T 1974 R-2 Oil on canvas
44⅞ × 118⅛ in. (114 × 300 cm.) Collection of
the Artist

T 1974 R-21 Oil on canvas
44⅞ × 118⅛ in. (114 × 300 cm.) Collection
of the Artist

T 1974 R-23 Oil on canvas
70⅞ × 70⅞ in. (180 × 180 cm.) Collection of
the Marguerite and Aimé Maeght Foundation,
Saint Paul de Vence, France

T 1974 R-24 Oil on canvas
43¹¹/₁₆ × 70⅞ in. (111 × 180 cm.) Private
Collection

T 1974 R-33 Oil on canvas
27¹⁵/₁₆ × 118⅛ in. (71 × 300 cm.) Collection of
the Artist

T 1975 E-20 Oil on canvas
44⅞ × 63⅞ in. (114 × 162 cm.) Collection of
the Artist

T 1975 R-35 Oil on canvas
70⅞ × 70⅞ in. (180 × 180 cm.) Collection of
the Artist

Monographs

Apollonio, Umbro. *Hans Hartung.* Fratelli Fabbri Editori, Milan, 1966 (English edition, Harry N. Abrams, New York, 1966; French edition, O.D.E.G.E., Paris, 1967).

Aubier, Dominique. *Hartung.* Georges Fall, Paris, 1961 (Collection "Le Musée de poche").

Gindertael, R.V. *Hans Hartung.* Pierre Tisné, Paris, 1960 (English edition, Universe Books, New York, 1961; German edition, Rembrandt Verlag, Berlin, 1962).

Grohmann, Will. *Hans Hartung: Aquarelle, 1922.* Erker Verlag, St. Gallen, 1966 (text in German, English, and French).

Rousseau, Madeleine and Domnick, Ottomar. *Hans Hartung.* Domnick Verlag, Stuttgart, 1949 (with a preface by James Johnson Sweeney).

Schmücking, Rolf. *Hans Hartung: Werkverzeichnis der Graphik 1921–1965.* Schmücking Gallery, Braunschweig, 1965 (catalogue raisonné of graphic work).

Siblik, Jiri. *Hans Hartung.* Odeon, Prague, 1967.

Tardieu, Jean. *Sur 10 pastels de Hartung.* Fernand Hazan, Paris, 1962 (Collection "Peintres d'Aujourd'hui").

Catalogues

1947 Paris, Galerie Lydia Conti. *Hans Hartung.* Preface by Madeleine Rousseau.

1949 London, Hanover Gallery. *Drawings of Hans Hartung and Peter Foldes.* Preface by Denys Sutton.

1952 Basel, Kunsthalle. *Walter Bodmer, Basel/Hans Hartung, Paris.*

1953 London, The Lefevre Gallery. *Hans Hartung.*

1954 Brussels, Palais des Beaux-Arts. *Hartung.* Catalogue by René de Solier.

1956 Paris, Galerie Craven. *Hans Hartung.* Preface by R.V. Gindertael.

1957 Hannover, Kestner-Gesellschaft. *Hans Hartung.* Catalogue by Werner Schmalenbach. New York, Kleemann Galleries. *Hans Hartung, Paintings.* Preface with quotations by Alfred Barr and René de Solier.

1958 Munich, Moderne Galerie Otto Stangl. *Hans Hartung.* Siegen, Siegerlandes Museum. *Hans Hartung.* Catalogue by W. Grohmann, F. Roh, W. Schmalenbach.

1959 New York, Kleemann Galleries. *Hans Hartung, Pastels, 1958.*

1960 London, Gimpel Fils. *Hans Hartung.* Essen, Galerie Van de Loo, *Hans Hartung, 21 Pastels.* Paris, Galerie de France. *Hans Hartung.* Stuttgart, Galerie Wolfgang Ketterer. *Hans Hartung.* On the occasion of the Venice Biennale.

1961 Cordoba, Galeria Liceo. *Hans Hartung.* Exhibition of pastels; catalogue by José de Castro Arines. Madrid, the Ateneo. *Hans Hartung.* Exhibition of pastels; preface by J. Vergara. Milan, Galleria Lorenzelli. *Hans Hartung.* Exhibition of pastels; preface by Giuseppe Marchiori. Paris, Galerie de France. *Hans Hartung: Œuvres de 1920 à 1939.* Turin, Galleria Civica d'Arte Moderna. *Hans Hartung.* Catalogue by Giuseppe Marchiori and Ezio Gribando.

1962 Paris, Galerie de France. *Hartung: Dix Peintures.*

1963 Dusseldorf, Kunstverein für die Rheinelande und Westfalen, Kunsthalle. *Hans Hartung.* Retrospective exhibition. Preface by Karl-Heinz Hering. Munich, Galerie Günther Franke. *Hans Hartung.* Preface by Günther Franke. St. Gallen, Galerie Im Erker. *Hans Hartung.* Preface by Werner Schmalenbach and J. Proal. Vienna, Museum des 20 Jahrhunderts. *Hans Hartung.* Zurich, Kunsthaus. *Hans Hartung.* Amsterdam, Stedelijk Museum. *Hartung.* Interview with artist by Werner Hofmann.

1965 New York, Associated American Artists. *Hans Hartung, Etchings and Lithographs.* Introduction by Sylvan Cole, Jr.

1966 Milan, Galleria Stendhal. *Hans Hartung: Pastels, Etchings, Lithographs.* New York, André Emmerich Gallery. *Hans Hartung, Paintings, 1966.* Paris, La Hune. *Lithographies nouvelles de Hans Hartung.* Turin, Galleria Civica d'Arte Moderna. *Hans Hartung.* Preface by Giuseppe Marchiori; catalogue by Luigi Malle.

1967 Genoa, Galleria La Polena. *Hartung.* Turin, Galleria Narciso. *Hartung.*

1968 Prague, Galerie Hollar. *Hans Hartung, graficke dilo.* Preface by Jiri Siblik.

1969 Houston, Museum of Fine Arts. *Hans Hartung.* Retrospective exhibition. Preface by Mary Hancock Buxton; text in French by Bernard Dorival. (Exhibition susbsequently traveled to Musée de Québec and Musée d'Art Contemporain, Montréal). Paris, Musée National d'Art Moderne. *Hans Hartung.* Retrospective exhibition. Preface by Bernard Dorival. Prague, Galerie Nardoni. *Hartung, Tapies, Johns, Hozo.* Exhibition of graphics. Hartung essay by Raymond Cogniat.

1971 Barcelona, Galería Metras. *Hartung.* New York, Lefebre Gallery. *Hans Hartung.* Text by Michael Gibson. Paris, Galerie de France. *Hans Hartung.* Accompanied by a poem by Jean Proal. Turin, Galleria d'Arte Gissi. *Continuita di Hartung.* Preface by Giuseppe Marchiori.

1973 Zurich, Galerie Maeght. *Hans Hartung, Peintures Récentes.* Text by Peter Althaus.

1974 Paris, Galerie de France. *Hans Hartung.* Interview with artist by François Le Targat. St. Gallen, Galerie Im Erker. *Hans Hartung, Grafik aus der Erker-Presse 1973.* Interview with the artist by Heidi Bürklin; short text by Eugene Ionesco. Cologne, Wallraf-Richartz-Museum. *Hans Hartung.* Retrospective exhibition. Text by Horst Keller. (Same catalogue for Hartung retrospective at the Stadtische Galerie, Munich, 1975.) Berlin, Nationalgalerie. *Hans Hartung.* Text by Werner Haftmann and Horst Keller.

General Articles

1936 Wescher, Herta, "New Work in Paris," *Axis,* London, no. 6, p. 27.

1938 Grohmann, Will, "L'Art Contemporain en Allemagne," *Cahiers d'art,* Paris, vol. 13, pp. 1–12.

1939 Morris, G.L.K., "Art Chronicle, Recent Tendencies in Europe," *Partisan Review,* New York, vol. VI, no. 5, pp. 31–33.

1947 Raymond, Marie, "L'Art Abstrait: une exposition à Paris," *Palaestra,* Amsterdam, October, pp. 20–21. Rousseau, Madeleine, "L'Art qu'on appelle abstrait," *Musée vivant,* Brussels, February, pp. 9–12.

1948 Raymond, Marie, "Kroniek: nouvelles réalités," *Kroniek van Kunst en Kultuur,* Amsterdam, April, p. 120.

1952 Degand, Léon, "Muss man Malerei verstehen?" *Antares,* Stuttgart, no. 2, pp. 66–68. Haesaerts, Paul, "A la recherche de l'espace," *XXe siècle,* Paris, January, pp. 13–26. Solier, René de, "La Biennale de Venise," *Preuves,* Paris, no. 17, pp. 45–48. Zervos, Christian, "Coup d'œil sur la XXVIe Biennale de Venise," *Cahiers d'art,* Paris, vol. 27, pp. 237–287.

1954 Bordier, Roger, "L'Art et la manière; Hartung ou l'improvisation travaillée," *Art d'aujourd'hui,* Paris, March–April, pp. 44–45.

1955 Brion, Marcel, "Problèmes et formes de la peinture abstraite," *Age nouveau,* no. 91, pp. 70–83. Guinard, Paul, "Tendencias recientes de la pintura francesa, 1945-1955," *Goya,* Madrid, vol. I, pp. 348–354. Lecomte, Marcel, "Reprise d'une problème," *Synthèses,* Brussels, vol. X, pp. 425–433. Trier, Eduard, "Französische Plastik des 20 Jahrhunderts," *Kunstwerk,* Krefeld, January, pp. 35–40.

1956 Raffhianti, Carlo L., "XXVIIIa Biennale di Venezia," *Sele arte,* Florence, May–June, pp. 2–88. Read, Herbert, "An Art of Internal Necessity," *Quadrum,* Brussels, no. 1, pp. 7–22.

1957 Brion, Marcel, "Qu'est-ce que l'art abstrait?", *Jardin des Arts,* Paris, April, pp. 348–358. Gindertael, R.V., "Peintres d'origine allemande en France, I. Les Créateurs," *Allemande aujourd'hui,* Paris, July–October, pp. 10–12, 25. Prossor, John, "An Introduction to Abstract Painting," *Apollo,* London, October, pp. 74–87.

1959 Weber, Gerhard, "Deutsche Maler in Paris," *Antares,* Stuttgart, pp. 20–25.

1960 Ashton, Dore, "How Informal Can We Get? (At The Biennale)," *Arts and Architecture,* London, October, pp. 6–7. Becker, Andreas, "La Peinture Allemande depuis Hans Hartung et Wols," *Ring des Arts,* Zurich, no. 1, pp. 120–125. Guéguen, Pierre, "Tachisme et désintégration," *Aujourd'hui,* Paris, April, pp. 4–5. Habasque, G., "La XXXe Biennale de Venise," *L'Œil,* Paris, September, p. 33. Morand, K., "Post-War Trends in the Ecole de Paris," *Burlington Magazine,* London, May, p. 191. Revel, Jean-François, "Tout un courant de la peinture actuelle attiré par la calligraphie," *Connaissance des Arts,* Paris, no. 106, pp. 126–135. Tillim, Sidney, "Report on the Venice Biennale," *Arts,* New York, October, p. 34.

1961 Anon., "Pourquoi les abstraits utilisent le clair-obscur," *Connaissance des Arts,* Paris, no. 111, pp. 60–67. Cassou, Jean, "Variations du dessin," *Quadrum,* Brussels, no. 10, p. 28. Gindertael, R.V., "Les refus," *XXe siècle,* Paris, December, pp. 13–20. Ragon, Michel, "Cent ans d'influence japonaise sur l'art occidental," *Jardin des Arts,*

Paris, October, pp. 36–45. Verdet, A., "Les Arts sur la Côte d'Azur," *Aujourd'hui*, Paris, October, p. 40.

1962 Mullins, E., "Ecole de Paris," *Apollo*, London, June, p. 299. Ragon, Michel, "A la recherche d'un nouvel espace pictoral," *XXe siècle*, Paris, February, p. 60.

1963 Dienst, R.G., "Informelle Schriften," *Kunstwerk*, Krefeld, April, p. 23.

1964 Hodin, J.P., "Quand les artistes parlent du sacré," *XXe siècle*, Paris, December, pp. 21–22.

1968 Popovitch, O., "Musée des Beaux-Arts de Rouen: l'art contemporain," *Revue du Louvre*, Paris, vol. 18, no. 6, p. 432.

1971 Cannon-Brookes, P., "Acquisitions of Modern Art by Museums," *Burlington Magazine*, London, February, pp. 119–120.

Articles about Hans Hartung

1949 Rousseau, Madeleine, "Hans Hartung," *Cahiers d'art*, Paris, no. 2, pp. 317–319. Stahly, F., "Ausstellung, Galerie Lydia Conti," *Werk*, Bern, June, p. 86.

1951 Anon., "Ausstellung, Galerie d'Art Moderne, Basel," *Werk*, Bern, June, p. 79. Degand, Léon, "Notes sur Hartung," *Art d'aujourd'hui*, Paris, March, pp. 23–25. Estienne, Charles, "Hans Hartung," *Art d'aujourd'hui*, Paris, March, pp. 20–22.

1952 Anon., "Ausstellung, Kunsthalle, Basel," *Werk*, Bern, April, p. 45. Solier, René de, "Hans Hartung," *Cahiers d'art*, Paris, July, pp. 86–91.

1953 Anon., Ausstellung, Galerie Marbach," *Werk*, Bern, April, p. 50. Melville, Robert, "Exhibition at the Lefevre Gallery," *Architectural Review*, London, April, p. 273.

1954 Gindertael, R.V., "Hans Hartung e il significato dell'arto di dipingere," *i 4 Soli*, Turin, pp. 14–15. Gindertael, R.V., "Hans Hartung," *Les Beaux-Arts*, Brussels, April 2, pp. 1, 14.

1955 Gindertael, R.V., "Hans Hartung," *Konstrevy*, Stockholm, vol. 31, no. 4, pp. 172–176. Seuphor, Michel, "Hans Hartung," *Art Digest*, New York, March 1, pp. 8–9.

1956 Clement, Virginia, "Le Réel irréel de Hans Hartung," *Aesculape*, Paris, February, pp. 73–80. Gindertael, R.V., "Peintures de la nouvelle generation: Hans Hartung," *XXe siècle*, Paris, June, pp. 34–37. Gindertael, R.V., "Hans Hartung," *Cimaise*, Paris, September–October, pp. 9–17. Restany, P., "Le Cas Hartung," *Prisme des arts*, Paris, November, pp. 13–15. Solier, René de, "Hans Hartung," *Quadrum*, Brussels, November, pp. 29–48.

1957 Anon., "Lines of Force," *Time*, New York, April 1, pp. 76–77. Degand, Léon, "Hartung," *Aujourd'hui*, Paris, January, pp. 32–35. P[ollett], E[lizabeth], "Exhibition at Kleemann Gallery," *Arts*, New York, April, p. 60. P[orter], F[airfield], "Exhibition of Oils at Kleemann Gallery," *Art News*, New York, March, p. 10. Prossor, John, "Paris Notes: Drawings at the Galerie Craven and Recent Work at the Galerie de France," *Apollo*, London, January, p. 29. Ringstrom, Karl K., "Un réaliste parmi les abstraits: Hans Hartung," *Jardin des Arts*, Paris, September, pp. 683–686. Watt, Alexander, "Exhibition at the Galerie de France," *The Studio*, London, March, p. 91.

1958 Gindertael, R.V., "L'Expression graphique et l'espace de Hans Hartung," *XXe siècle*, Paris, March, p. 18.

1959 Aubier, Dominique, "Hans Hartung et l'urgence de peindre," *XXe siècle*, Paris, May–June, pp. 29–34. B[urckhardt], E[dith], "Exhibition at Kleemann Gallery," *Art News*, New York, May, p. 16. Michelson, Annette, "Drawings at the Galerie de France," *Arts*, New York, January, p. 18. Mock, Jean-Yves, "Notes from Paris and London: Hartung at the Galerie de France," *Apollo*, London, February, p. 47. Mock, J.-Y., "Richier and Hartung at the Musée Grimaldi, Antibes," *Apollo*, London, October, p. 103. M[unsterberg], H[ugo], "Exhibition at Kleemann Gallery," *Arts*, New York, April, p. 50. S[andler], I[rving] H., "Exhibition at Lefebre Gallery," *Art News*, New York, January, p. 14. Verdet, A., "Hans Hartung au Musée d'Antibes," *XXe Siècle*, Paris, December, p. (supp.) 45.

1960 Argan, Giulio Carlo, "Hartung e Fautrier," *Commentari*, Florence, vol. XI, pp. 164–168. Aubier, Dominique, "Hans Hartung," *Camera*, New York, August, pp. 4–17. Gindertael, R.V., "La Poétique de Hartung," *Jardin des Arts*, Paris, October, pp. 36–45. Jouffroy, Alain, "Biographie des peintres: Hans Hartung," *Jardin des Arts*, Paris, April, pp. 56–88. Marchiori, Giuseppe, "Hartung: l'œuvre première," *XXe siècle*, Paris, June, pp. 53–61. Melville, R., "Exhibition at Gimpel's," *Architectural Review*, London, February, p. 133. Reichart, J., "Hans Hartung at Gimpel Fils," *Apollo*, London, November, p. 160. Restany, P., "Hans Hartung der geopferte Sieger auf der Bien-

nale," *Kunstwerk,* Krefeld, July, pp. 73–74. Sougez, E., "Controversy about Hartung," *Camera,* New York, August, p. 18. Strauss, H., "Exhibition at Gimpel Fils," *Burlington Magazine,* London, December, p. 551. Verdet, A., "Pleines vacances de Hans Hartung," *XXe siècle,* Paris, December, pp. 97–101.

1961 Anon., "Hartung chez lui," *Aujourd'hui,* Paris, October, pp. 56–57. Bernard, Dorival, "Don de quatre pastels au Musée d'art moderne," *Revue de Louvre,* Paris, vol. 11, no. 21, pp. 90–91. C[ampbell], L[awrence], "Exhibition at Thibaut Gallery," *Art News,* New York, October, p. 13. Guéguen, P., "Hans Hartung, le précurseur," *Aujourd'hui,* Paris, May, p. 19. Haftmann, Werner, "Mutamenti formali nell'opera di Hans Hartung," *Biennale de Venezia,* no. 42, pp. 2–14. Mellquist, J., "New Links: Retrospective at the Galerie de France," *Apollo,* London, August, pp. 44–46. Raynor, V., "Exhibition at Thibaut Gallery," *Arts,* New York, November, p. 46. S[awin], M[artica], "Exhibition at Lefebre Gallery," *Arts,* New York, January, p. 56. Volta, Candido, "Conversazione con Hartung," *Metro,* Milan, no. 3, pp. 9–17. Watt, Alexander, "Visages d'artistes: Hans Hartung," *Studio,* London, July, pp. 9–11.

1962 Frigerio, Simone, "Exposition à Paris," *Aujourd'hui,* Paris, November, p. 62. Gindertael, R.V., "L'Art exemplaire de Hartung," *XXe siècle,* Paris, June, pp. 45–48.

1963 Clay, J., "Hans Hartung, la vie d'un peintre qui a mis sa marque sur les formes modernes," *Réalités,* Paris, May, pp. 83–88. Frigerio, Simone, "Suisse: réflexions sur quelques rétrospectives," *Aujourd'hui,* Paris, May, p. 52. Gindertael, R.V., "Hartung," *Quadrum,* Brussels, no. 14, pp. 59–70. H.R., "Ausstellung in St. Gallen," *Werk,* Bern, December, p. (supp.) 270. Moholy, L., "Exhibition in Zurich," *Burlington Magazine,* London, April, p. 184. Schneider, P., "Recent Canvases at the Galerie de France," *Art News,* New York, January, p. 45. Volboudt, Pierre, "Hans Hartung: une thématique de l'espace," *XXe siècle,* Paris, May, pp. 19–25.

1964 Conil-Lacoste, Michel, "Exciting Renewal for Hartung?", *Studio,* London, September, p. 126. Dypréau, J., "Hartung à Bruxelles et à Amsterdam," *XXe siècle,* Paris, May, p. (supp.) 21. Frigerio, Simone, "Hartung," *Aujourd'hui,* Paris, April, pp. 38–39. Gindertael, R.V., "Œuvres récentes de Hartung," *XXe siècle,* Paris, December, p. 130.

1965 Frigerio, Simone, "Braunschweig: l'œuvre graphique de Hartung," *Aujourd'hui,* Paris, July, p. 95.

1966 Bigongiari, Piero, "Hartung tra matiera e antimateria," *Letteratura,* Rome, no. 84, pp. 53–61. Bonzal, Fernandez, "Hartung, signo y significado," *Artes,* Madrid, May, pp. 15–20. B[urden], S[cott], "Exhibition at Emmerich Gallery," *Art News,* New York, December, p. 12. Fezzi, Elda, "Il Limbo incantato di Hartung," *Arti,* Milan, no. 2, pp. 18–21.

1967 W[aldman], D[iane], "Exhibition at Emmerich Gallery," *Art News,* New York, February, p. 15.

1968 Descargues, P., "Evolution de Hartung," *XXe siècle,* Paris, December, pp. 41–48. Popovitch, O., "Musée des Beaux-Arts de Rouen: l'art contemporain," *Revue de Louvre,* Paris, vol. 18, no. 6, p. 432.

1969 Clay, J., "La Rétrospective Hans Hartung au Musée national d'art moderne," *XXe siècle,* Paris, June pp. 149–150. Peppiatt, Michael, "Paris Letter," *Art International,* Lugano, March, pp. 52–53. Solier, René de, "Hans Hartung," *Vie des arts,* Montreal, no. 55, pp. 20–25.

1970 Catalano, Tullio, "Hans Hartung: significazione e significazione," *Arte e poesia,* Rome, no. 7, pp. 119–124. Gállego, J., "Un Premio a Hans Hartung," *Goya,* Madrid, September, p. 101.

1971 Atirnomis, "Exhibition at Lefebre Gallery," *Arts,* New York, March, p. 60. Castillo, A. del, "Exposición Galería Metrás, Barcelona," *Goya,* Madrid, July, p. 42. D[ownes], R[ackstraw], "Exhibition at Lefebre Gallery," *Art News,* New York, March, p. 20. Gállego, J., "Exposición Fundación Maeght," *Goya,* Madrid, July, p. 36. Glueck, Grace, "Exhibition at Lefebre Gallery," *Art in America,* New York, January, p. 24. Verdet, A., "Eblouissement de Hans Hartung," *XXe siècle,* Paris, December, pp. 21–32.

1972 anon., "Exposition à la Galerie de France," *Connaissance des Arts,* Paris, January, p. 13. Martory, Pierre, "Exhibition at the Galerie de France," *Art News,* New York, March, p. 52. Schwartz, Ellen, "Paris Letter: Exhibition at the Galerie de France," *Art International,* Lugano, January, p. 55.

1973 Clay, J., "Toiles récentes de Hartung à la Galerie Maeght, Zurich," *XXe siècle,* December, pp. 27–32. Daval, Jean-Luc, "Lettre de Suisse: Exposition à la Galerie Maeght," *Art International,* Lugano, Summer, p. 73. Vallier, Dora, "Hartung et le geste de peindre," *XXe siècle,* Paris, December, pp. 33–37.

1974 anon., "Le Musée Wallraf-Richartz de Cologne fête les 70 ans du peintre," *Connaissance des Arts,* Paris, March, p. 19. Anon., "Exposition à la Galerie de France," *L'Œil,* Paris, June, p. 59. Cogniat, Raymond, "Hans Hartung," *L'Œil,*

Paris, September, pp. 18–19. Dorival, Bernard, "Les 70 ans d'Hartung," *L'Œil,* Paris, September, pp. 12–17. Gilles, S., "Hartung photographe," *L'Œil,* Paris, September, pp. 42–45. Peppiatt, Michael, "Paris: Exhibition at the Galerie de France," *Art News,* New York, September, pp. 60–61. Schurr, Gerald, "Europe: Exhibition at the Wallraf-Richartz-Museum," *The Connoisseur,* October, p. 136. An issue of *Cimaise,* Sept.–Oct.–Nov.–Dec., 1974, was devoted to Hans Hartung on the occasion of his seventieth birthday. The following articles, devoted to aspects of his work, comprised the contents: Abadie, Daniel, "Les Intuitions de Hans Hartung";

Arnaud, Jean-Robert, "Editorial (Hartung)"; Bordier, Roger, "Hartung pris à sa source"; Bourniquel, Camille, "Présence de Hartung"; Bouyeure, Claude, "Hartung ascèse éclatante"; Bürklin, Heidi, "Conversation avec Hans Hartung"; Clay, J., "Interview d'Anna-Eva Bergman"; Gauthier, Paule, "Hartung photographe"; Geldzahler, Henry, "Peintures récentes"; Gindertael, R.V., "L'Œuvre: les principales périodes"; Lefebre, John, "La Grande Pause: un New-Yorkais se souvient des années vingt à Berlin"; Ragon, Michel, "Hartung et l'architecture"; Vallier, Dora, "La Position historique de Hartung".

Printed in Switzerland